DOVER
IN OLD PHOTOGRAPHS

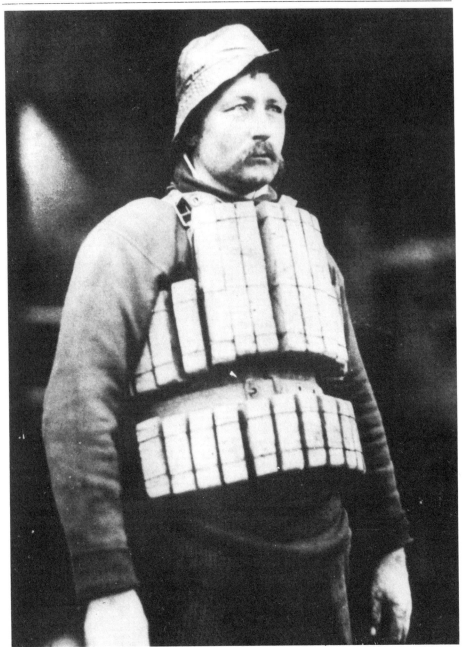

COXSWAIN COLE. Mr William Cole was the coxswain of the lifeboat from 1901–2 and again, from 1906–9. He is seen here wearing a cork life preserver and sou'wester, the standard kit at the time. *Circa* 1906.

DOVER
IN OLD PHOTOGRAPHS

COLLECTED BY
MARK SMITH

ALAN SUTTON
1988

Alan Sutton Publishing Limited
Brunswick Road · Gloucester

First published 1988

British Library Cataloguing in Publication Data

Dover in old photographs.
1. Kent. Dover, history
I. Smith, M.P.
942.2′352

ISBN 0-86299-512-4

Typesetting and origination by
Alan Sutton Publishing Limited.
Printed in Great Britain by
WBC Print Limited.

CONTENTS

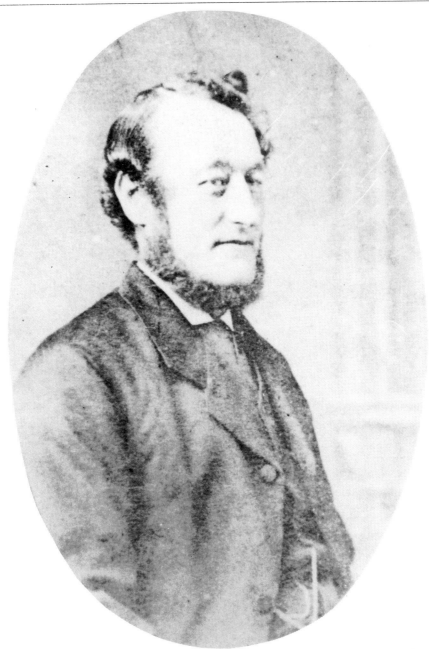

WILLIAM ALEXANDER YOUNG MARSH was a Dover pilot who drowned off Dungeness when SS *Severn* was in collision with the Trinity House Pilot Cutter *Edinburgh* on 14 March 1879. *Circa* 1875.

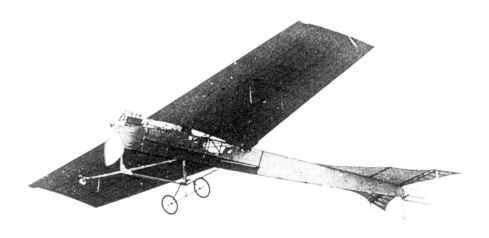

CHANNEL FLIGHT ATTEMPT. On 10 July 1909 and before Bleriot's triumph, Hubert Latham, an Englishman, attempted to cross the Channel. Unfortunately, Mr Latham was forced to abandon his attempt when he ditched into the sea, though he himself was unhurt.

INTRODUCTION

With some 14 million people passing through its port annually, Dover must surely be one of, if not *the*, most visited towns in Britain. And yet here is a paradox for, despite the great numbers that pass through, only a few actually stop to see what is one of this country's most historic towns with many places of interest.

This book of over 250 photographs, all selected from the large collection held by Dover Museum, captures a small segment of the town's past from the early days of photography to 1936.

Local people, visitors and historians will find much of interest in these old views of the town and port, as Dover's unique location as the closest port of Britain to the Continent has encouraged not only many famous travellers but many singular events of national importance.

For example, the arrival of Louis Bleriot in Dover in the summer of 1909, the first man to cross the Channel by aeroplane. It is said that so perplexed were the authorities by his arrival that his little monoplane was registered as a 'yacht' by the Customs as no appropriate category was available.

Equally famous is the marathon swim of Capt. Matthew Webb in 1875, the first man to swim the Channel. This heroic feat took an incredible 21¾ hours. (Webb, a larger than life character was to die some 13 years later during an attempt to swim the rapids and whirlpools below Niagara Falls, described by Webb as 'the angriest piece of water in the world'.)

A multitude of famous and titled people have also visited and stayed in Dover. For centuries Dover Castle was a Royal palace frequented by kings such as Henry V returning from the Battle of Agincourt or by Henry VIII who took a personal interest in the development of the harbour. Before the development of air travel most heads of state and Royal personages departed for the Continent or arrived in Britain via Dover's harbour.

Today many thousands of people visit one of Dover's best-known sights, the medieval castle which overlooks the town. Early photographers often chose the castle as a subject and several of their views have been included here. Views of other surviving historic buildings, including the medieval Pilgrim's Hospice, now the Town Hall, can also be seen as well as views which now, alas, can only be seen in photographs or original paintings because the buildings themselves are no more.

There are many personal stories here, many long forgotten such as that of Thomas Longley, landlord of the Star Inn at Dover – 'her majesty's heaviest subject', who achieved a top weight of 593lb.! Other pictures show tragic accidents such as the Crabble Hill tram disaster of 1917, when eleven people died. Also pictured is Lieut. George Thompson, Dover's coroner, who was, with a Sgt. Monger, killed when a cannon exploded during a practice firing. Ironically, an inquest into the incident had to be delayed whilst another coroner was found to conduct the proceedings.

All the photographs in this book have been selected and re-photographed by Mark Smith, currently working as a historical researcher at Dover Museum. Anyone requiring copies of the photographs or with enquiries about the book may contact the Museum, which is based in Ladywell, Dover. People wishing to view the entire photographic collection are very welcome to do so by appointment.

Finally, the next time you are passing through Dover consider the words of William Cobbett, writing in his *Rural Rides* of 1823. Normally scathing in his description of towns, Dover seems to have appealed to him:

The Valley that runs down from Folkestone is, when it gets to Dover, crossed by another valley that runs down from Canterbury or at least from the Canterbury direction. It is in the gorge of this valley that Dover is built. The two chalk hills jut out into the sea and the water that comes up between them forms a harbour for this ancient most interesting and beautiful place.

So why not stop here too and discover its history for yourselves?

Christine Waterman
Curator of Dover Museum

SECTION ONE

Harbour

For centuries, Dover's proximity to the coast of France has profoundly affected the nature and people of the town, from the twin Roman lighthouses on the hills above the ancient estuary mouth to the extensive artificial developments that have continued to the present day.

That river, the Dour, which gave Dover its name, became blocked by shingle and silt and therefore unnavigable. An area of water, closed in from the sea, gave rise to a dock known as the Pent. Piers were constructed to prevent the docks becoming blocked by the effects of coastal drift. These docks encouraged supporting trades onto the quayside and Commercial quay was born. After much alteration over the years, including deepening, the Pent and the Basin have developed into Wellington and Granville Docks respectively. Both are named after former Lord Wardens of the Cinque Ports – the Duke of Wellington and Lord Granville.

The old docks only survived because of extensive work. In the early 1870s what is now Granville Dock was deepened to accommodate large vessels. After removing the sludge at the bottom of the dock up to 10ft. of chalk was removed by pick and shovel.

North and South Piers were constructed in the sixteenth century to allow access to the dock. Castle Jetty, towards the east cliff, was completed in 1754 to help the beach accumulate and was lengthened in 1833. Only a short piece of the jetty remains.

Many details come and go, such as the twin towers of a compass tower and a clock tower built on the Crosswall in 1830 by James Moon, a harbourmaster and engineer. When the towers were removed the clock was incorporated in the new tower. The compass tower however disappeared forever. The Admiralty Pier gun turret, a gun built into the pier to protect the harbour from attack, was almost obsolete even before it was finished and only ever fired once.

The Promenade Pier, which attempted to provide a greater scope for Dover, failed dismally. Designed by the competition winner, a Mr Webster from Liverpool who received the £100 prize, a pavilion was added in 1901. However, before its end in 1927, the body of Nurse Cavell was landed here, as was that of

Capt. Fryatt, Belgian hero of the SS **Brussels***, who was captured and executed by the Germans after the raid on Zeebrugge.*

The developments that expanded the port, the lengthening of the Admiralty Pier, the eastern arm and the building of the breakwaters, cost an estimated £2,000,000 when the years of discussion finally became a reality in 1902.

The changing times have altered the harbour at Dover through the years and the development continues even today to meet not the challenge of natural conditions but the re-emergence of the idea of a fixed link between Britain and the Continent.

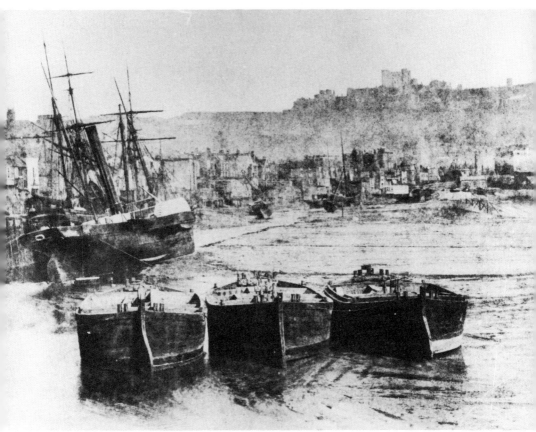

WELLINGTON DOCK. This is a view of Wellington Dock looking east towards the castle from Union Street. Formerly called the Pent, it was renamed after the Duke of Wellington in recognition of his work as Lord Warden of the Cinque Ports. *Circa* 1870.

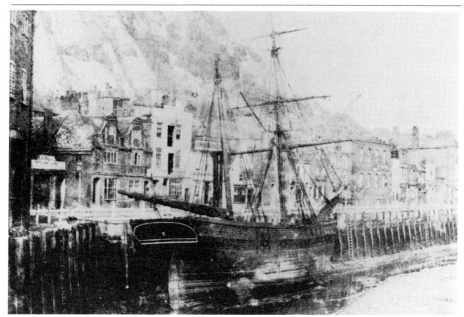

COMMERCIAL QUAY received its name because of the trade that grew alongside the quayside at Wellington Dock. The wooden building behind the ship is King's Ship Chandlers and the Commercial Quay public house can be seen through the rigging. *Circa* 1890.

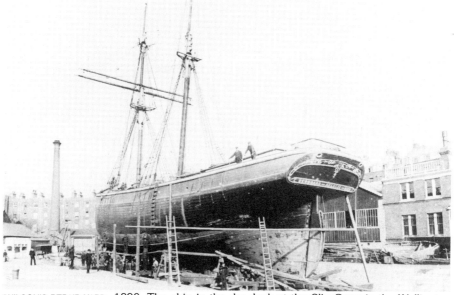

SHILSON'S REPAIR YARD, 1890. The ship in the dry dock at the Slip Quay in the Wellington Dock, is the German vessel, *Bernhard und Auguste von Rica*. The owner of the yard in 1890 was George Richard Shilson.

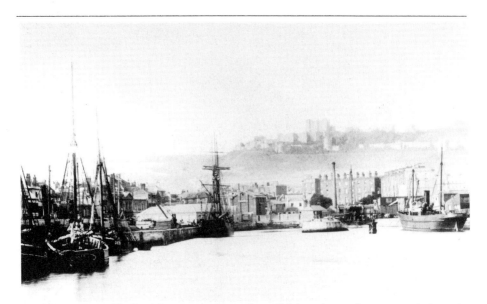

WELLINGTON DOCK. To the left are a number of small fishing boats that operated along the Channel coast. To the right of the chimney stack is the Slip Quay with a ship in the dry dock of the repair yard. *Circa* 1890.

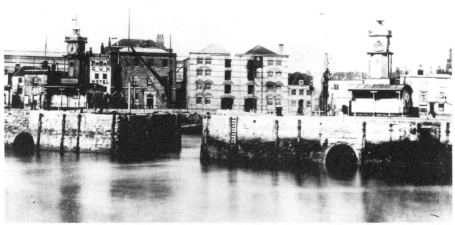

CROSSWALL. Separating the Tidal Harbour from the Basin (renamed Granville Dock in 1874) is the Crosswall. The twin clock (right) and compass (left) towers, built on the Crosswall in 1830, were removed in 1877. In the background is Commercial Quay, including the Gun Hotel, (built 1792, demolished 1904). To the left of the clock tower is E. Hutley Mowell's Wine and Spirit merchants. *Circa* 1870.

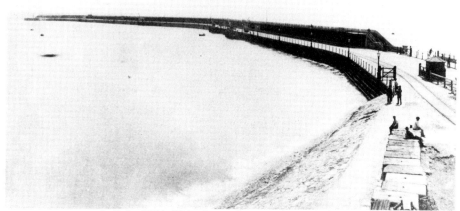

ADMIRALTY PIER was built in 1871. This shows the pier shortly before the gun turret or the lighthouse were built.

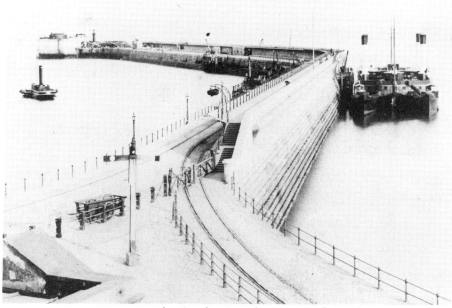

ADMIRALTY PIER WITH GUN TURRET showing the pier railway and the *Calais–Douvres* alongside. At the end of the pier is the gun turret built to protect the harbour from threat. *Circa* 1881.

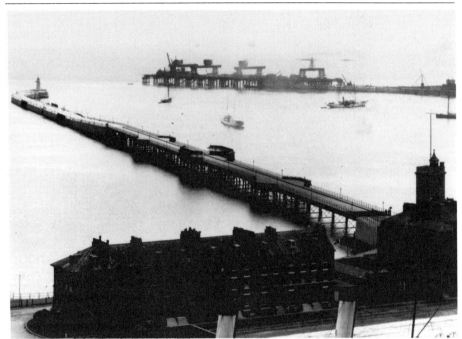

PRINCE OF WALES PIER (named in honour of Edward VII) in 1902, the buildings along the Esplanade and the clock tower (built 1871). Admiralty Pier is being extended.

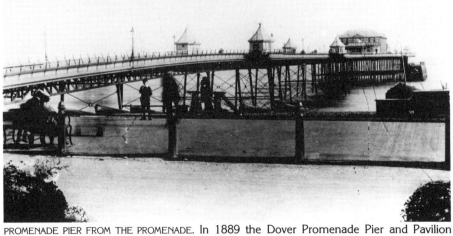

PROMENADE PIER FROM THE PROMENADE. In 1889 the Dover Promenade Pier and Pavilion Company was formed to build a new pier at the promenade which was completed in 1893. In 1901 a pavilion was added at the end of the pier.

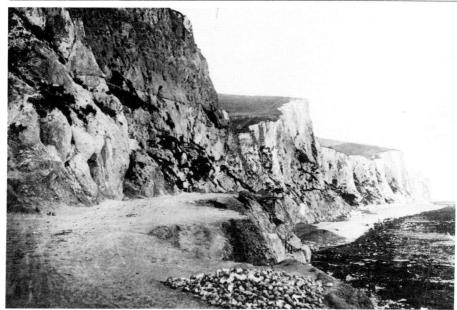

EAST CLIFF 1850. A view of the eastern cliffs towards Fan Bay and Langdon Bay prior to the Eastern Docks development.

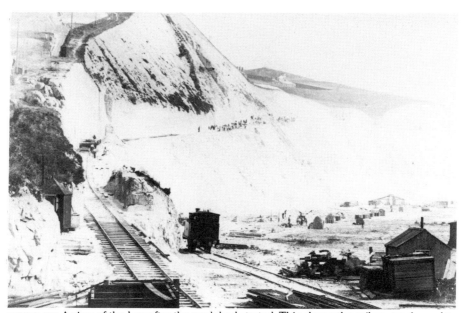

EAST CLIFF. A view of the bay after the work had started. This shows the railway track used to transport the chalk up the cliff and away from the site. The building on the cliff is Langdon Prison built in 1854.

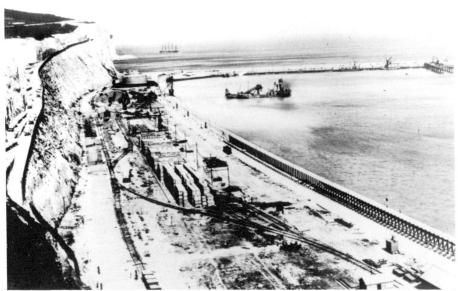

THE BLOCK-MAKING YARD from the cliff showing the work in progress. The ship in the background is the *Preussen* which ran aground in November 1910 in Langdon Bay. A dredger is working on the camber and the South Pier Jetty is under construction.

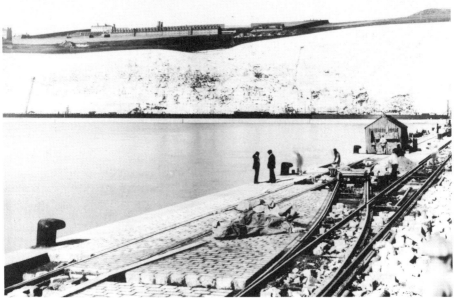

A VIEW FROM THE EAST ARM showing the railway line used for transporting the materials to build the breakwater. This also gives a front view of the Langdon Prison. 12 October 1908.

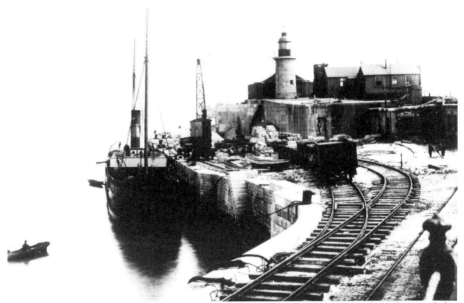

ADMIRALTY PIER TURRET-WIDENING. Looking along the pier showing the railway line and the lighthouse on top of the turret. The buildings to the right are where the lighthouse keeper and his family lived. 1903.

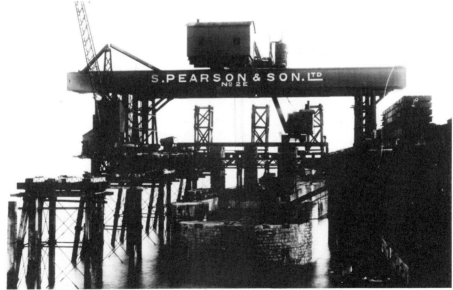

SOUTH BREAKWATER. The east head of the South Breakwater under construction. The large machine by S. Pearson & Son was called a Goliath and was used to place the concrete slabs in position. 1907.

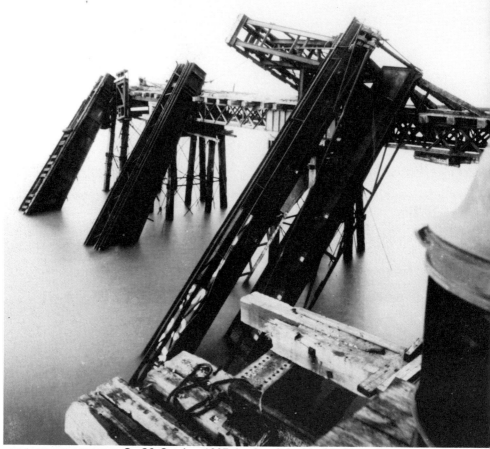

BREAKWATER ACCIDENT. On 20 October 1907 the Swedish ship SS *Olaus Olsson,* carrying timber, collided with the South Breakwater knocking two cranes into the harbour. The work was set back by several months. A slight accident involving the liner *Deutschland* shortly after led to the withdrawal by all liners from Dover.

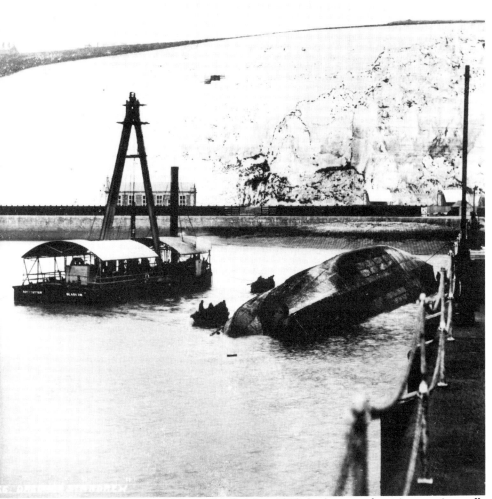

THE DREDGER *ST ANDREW* which, on 14 October 1910, broke away from its moorings off Waterloo Crescent amidst gales and heavy seas and, after capsizing in the harbour, was driven ashore. Fortunately there was no loss of life and it was soon righted.

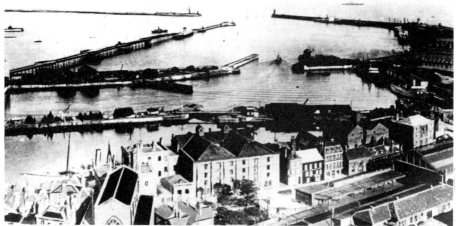

WESTERN DOCKS from the western heights after the completion of the Admiralty harbour with Trinity Church in Strond Street in the foreground. To the right is the Harbour railway station.

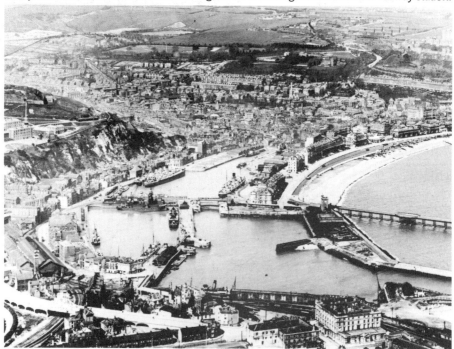

AN AERIAL VIEW ABOVE THE WESTERN DOCKS looking towards the town and harbour with the Drop Redoubt on the Western Heights to the left. *Circa* 1927.

Cross-Channel

From the time of the Roman invasion and the building of the twin lighthouses on the hills above Dover which guided the Roman ships to the estuary of the River Dour, Dover's history has been linked with the need to move from the continent of Europe to this small island, over twenty-two miles of water which have caused their share of pain and elation.

The Channel has proved not only unavoidable for the traveller but also acted as a draw for its fair share of adventures. There has never been a shortage of those who have attempted a crossing by a variety of traditional means or by less orthodox ones; indeed one man tried rowing across on a plank (he failed).

In 1909 a Frenchman, Louis Bleriot, completed an achievement which caused consternation amongst locals and officials alike. Bleriot won the

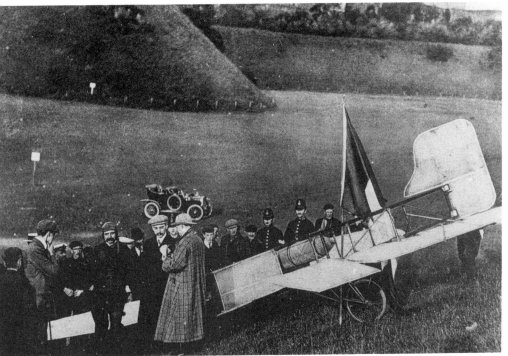

BLERIOT'S ARRIVAL IN DOVER. On the 25 July 1909, the Frenchman Louis Bleriot, in his Bleriot XI, became the first man to fly across the Channel. He landed at Northfall Meadows near the castle, winning himself £1,000 in prize money. He received a rousing reception from the locals and was registered by perplexed authorities as a 'yacht'. Later a granite aeroplane-shaped memorial was set into the meadow near the site of the landing.

£1,000 prize money on offer. Had Hubert Latham (see p. 7) managed the same achievement just fifteen days earlier, his would have been the fame and a prize of £10,000 offered by the Daily Mirror on being an Englishman to complete the first crossing.

Just a year after the first crossing, it was possible to fly from England to France and back again, non-stop. On 2 June 1910, the Hon. Charles Stewart Rolls, of Rolls-Royce fame, an enthusiastic flyer, completed a double trip that took just an hour and a half. Unfortunately, he was killed shortly after in a flying accident and a memorial stands on the promenade.

Vying with Bleriot's flight as the most famous cross-Channel exploit was that of Capt. Matthew Webb. Webb had been contemplating the channel swim for two years when the American Capt. Paul Boyton demonstrated C.S. Merriman's life-saving suit by paddling himself across the Channel in May 1875. Webb determined to swim across without any artificial aids. Delayed on 12 August by persistent rain and heavy seas, Webb set off from Dover on the 24 August, accompanied by the trawler, Ann, and two rowing boats, the crews of which had to declare that they assisted Webb with nothing more than encouragement and refreshment. Despite being stung on the shoulder by a jellyfish, Webb swam 39½ miles in 21 hours and 45 minutes.

Webb's races and demonstrations of swimming and diving brought him international fame. In 1879 a 15-mile swim in America brought him $1000. When he stayed afloat in Westminster Aquarium for 60 hours, 15,000 visitors came to see him and raised £277 11s. 3d. It was not therefore surprising that the challenge of swimming the rapids beneath the Niagara Falls appealed to Webb, even though Webb himself had described it as 'the angriest bit of water in the world'. It proved too angry for Webb who was sucked under and his body was found with head wounds. He was buried in Niagara and a memorial was placed on the Dover seafront in 1910.

Webb's record, however, took a long time to be broken. In 1923 Enrico Tirabosni, an Italian, swam from France to England in 16 hours and 33 minutes, 48 years after Webb's first crossing. In 1934, Edward Temme broke Webb's England to France record in a time of 15 hours and 34 minutes, a staggering 59 years after Webb.

However, while the Channel is the scene of triumph, tragedy is never far away and a hostile sea has also brought grief and destruction. There has been a lifeboat stationed in Dover for more than 150 years, before the Royal National Lifeboat Institution, when the boats were provided by the Humane Society, a recognition of the danger in these waters. In that time more than 600 people have been grateful for their presence.

A hostile sea has no respect for size or circumstance. In November 1910 the Preussen, then the largest sailing ship in the world, ran aground in Langdon Bay below the lighthouse. Even today, at extremely low tides, the hull of the ship can be seen from the clifftop.

There have been lighthouses, ancient and modern, lifeboats, pilot houses and many attempts at building tunnel links between Britain and France, yet the twenty-two miles of sea still form a major barrier.

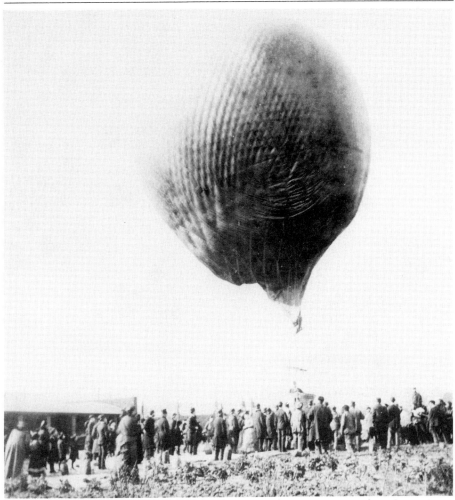

FIRST SOLO BALLOON CROSSING. In 1882, Col. Fred Burnaby, commander of the Royal Horse Guards, became the first man to cross the channel solo by balloon. He left Dover from the gasworks and arrived 18 miles south-west of Dieppe. He was accompanied, in his 38,000 cub. ft. balloon by 20 bags of sand, some newspapers, sandwiches and a bottle of Appollinaries mineral water.

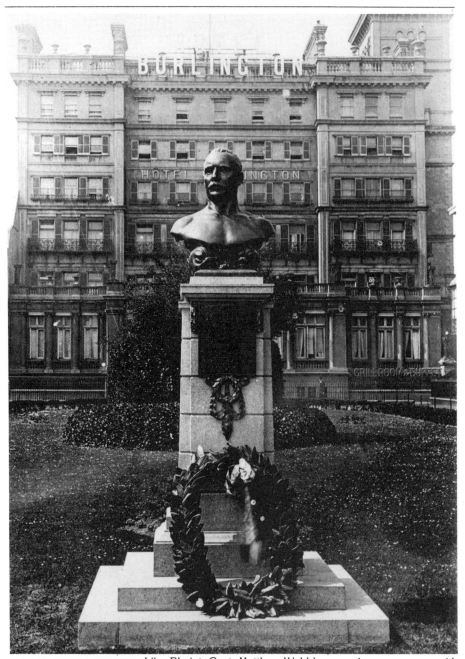

MATTHEW WEBB'S MEMORIAL. Like Bleriot, Capt. Matthew Webb's name is synonymous with Dover. On 8 June 1910, this memorial was unveiled in front of the Burlington Hotel and now stands on the promenade.

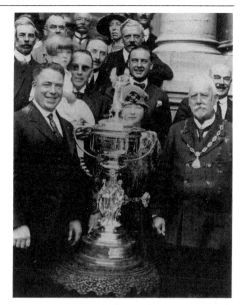

MR SULLIVAN RECEIVING HIS PRIZE 1933: Alderman Bussey JP and Deputy Mayor, presenting a cup to Mr Sullivan for swimming the channel in 1933, on the steps of the Town Hall.

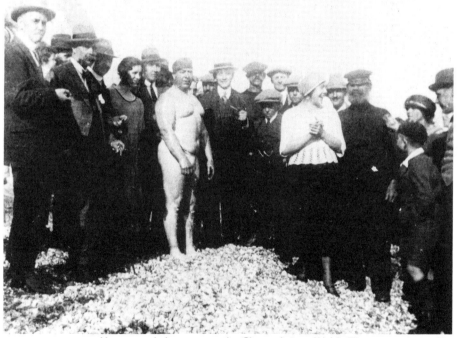

UNKNOWN SWIMMER. Many people have swum the Channel since Webb. The vast majority, like this man, have become anonymous with time. It was over fifty years before Webb's record was broken. *Circa* 1900.

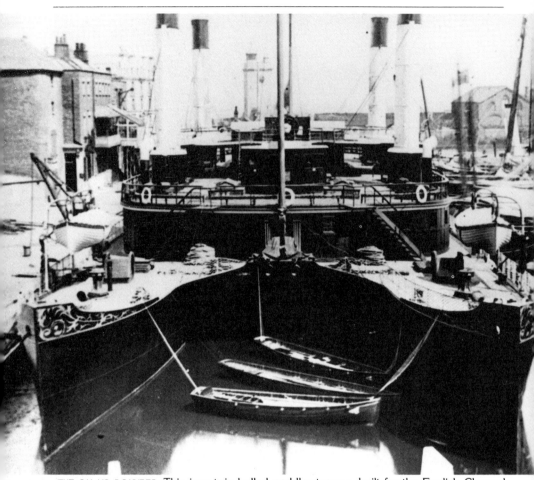

THE *CALAIS–DOUVRES*. This iron twin-hulled paddle-steamer, built for the English Channel Transit Co. entered service on the Dover route in 1878, the third and last of the 'Peculiars' (the other two were its sister ships *Castalia* and *Bessemer*). A seasonal vessel, it was withdrawn from service in 1888 and sold to a London coal merchant. *Circa* 1878.

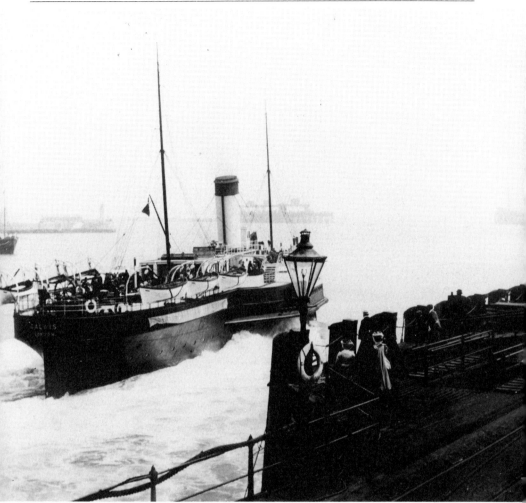

THE SS *CALAIS*. A more usual example of the channel ferries that operated in Dover. The SECR's *Calais* arrived in Dover in 1896 and was sold to French owners in 1911. Renamed *Au Revoir* the liner tender was sunk in 1916 by a German submarine, U-18.

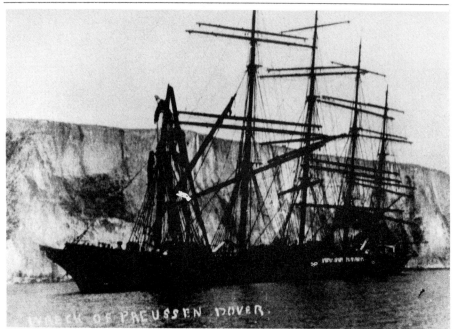

WRECK OF THE *PREUSSEN*. On the night of 6 November 1910, the SS *Preussen* ran aground in Langdon Bay under the South Foreland Lighthouse. At the time the vessel was the largest sailing ship in the world.

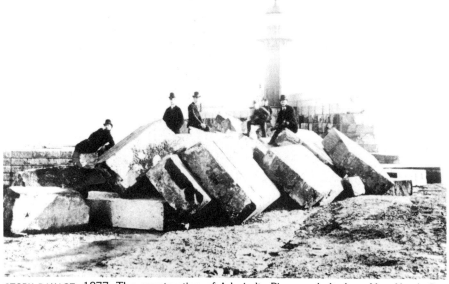

STORM DAMAGE, 1877. The construction of Admiralty Pier was halted on New Year's Day 1877 following severe damage when 900ft. of the pier was washed away.

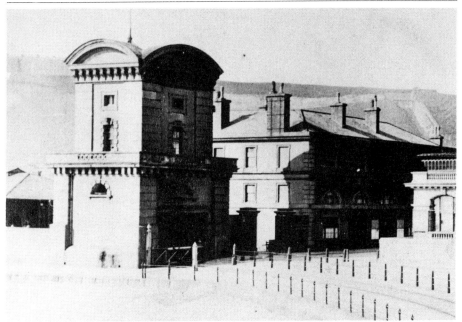

PILOT HOUSE. The Pilot House that stood on the seafront was built in 1847 (and was used as the telegraph station). It was demolished in March 1914 to form the approach for the railway.

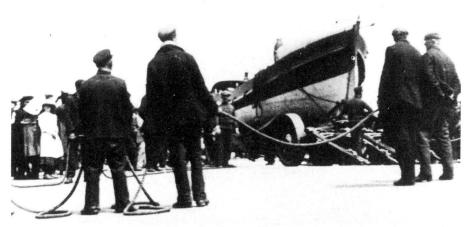

LAUNCHING THE DOVER LIFEBOAT. There has been a lifeboat stationed at Dover for more than 150 years. This is the RNLI lifeboat *Mary Hamer Hoyle* in 1906, a 37ft., 12-oar boat which was stationed at Dover from 1901–14.

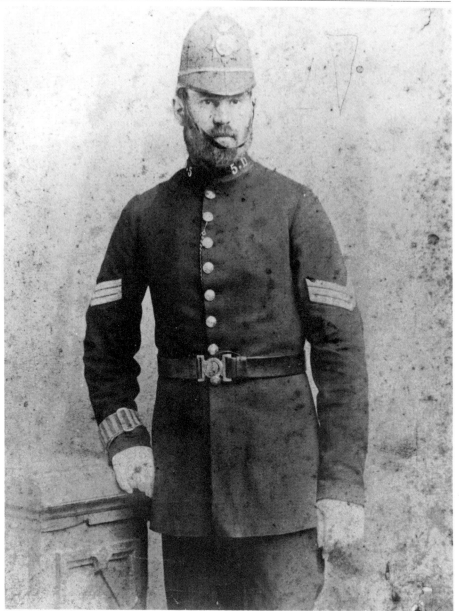

INSPECTOR ALFRED NASH who, in 1903, was killed in a bizarre accident. Whilst helping to launch the lifeboat, he was run over by one of the carriage wheels. The RNLI paid for the funeral and a fund raised £100 for his widow. *Circa* 1895.

Dover Castle

Described by Matthew Paris in the thirteenth century as 'the Key of England', the castle stands in an unrivalled position of authority over Dover. From an Iron Age earthwork, home to the Roman pharos or lighthouse and the Saxon church of St Mary-in-Castro, a Norman castle grew, strengthened in preparation to meet any invading foe through the ages. Tudor, medieval, Napoleonic and modern wars have left their mark upon the castle and much below it too.

Having been in use for hundreds of years the castle was neglected following the restoration of the monarchy, remaining in the hands of parliament until a series of Victorian refurbishments resulted in the castle that can be seen today.

Of all the features in the castle the keep, built from Kentish rag and Caen stone, is one of the best in the country. It contains many chambers, apartments and two small chapels. With its walls reaching a height of 95ft. and a thickness of up to 21ft., it cost about £4000 to build in the twelfth century.

The pharos, the Roman lighthouse which pre-dates any other part of the castle, would originally have been anything up to 80ft. in height and stands alongside the late Saxon church of St Mary-in-Castro. Octagonal from the outside, it is rectangular on the inside, and was used as a bell tower until the bells were removed to Portsmouth by Sir George Rooke, victor at Gibraltar. The remains of a second pharos are inside the Drop Redoubt on the Western Heights opposite the castle.

Another interesting feature is Queen Elizabeth's Pocket Pistol. Cast in Utrecht in 1544, this ornately decorated gun was used during the Civil War as part of the King's artillery. With a calibre of over 4in. and measuring 24ft. in length this gun is reputed to have thrown a shot 7 miles. The ornamental gun carriage on which it rests was made in 1827.

During wartime the castle once again became the centre of operations. New underground workings were added to existing ones and these will hopefully be opened to the public, having remained secret for many years. Through it all the castle remains a powerful reminder of Dover's strength.

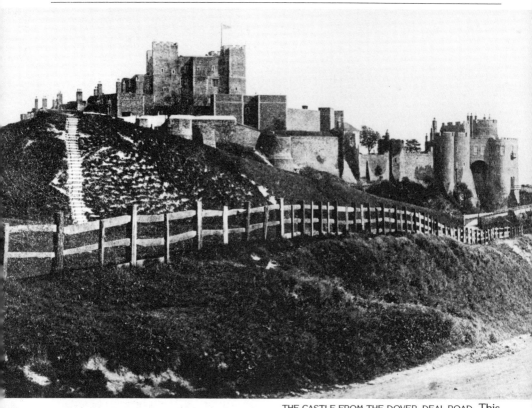

THE CASTLE FROM THE DOVER–DEAL ROAD. This view has been the most popular with engravers and photographers. Godfoe Tower (also known as Devil's Tower) to the left of Constable's Tower, was built by John de Fiennes when Stephen de Pencester was Constable of the Castle. The square Clopton, or Treasurer's, Tower was once the record office of the castle. The castle was first opened to the public, afternoons only, in 1880 and is now administered by English Heritage.

THE BANQUETING HALL IN THE KEEP OF THE CASTLE. The keep consisted of two floors conceived as self-contained residential suites which included their own well and two small chapels.

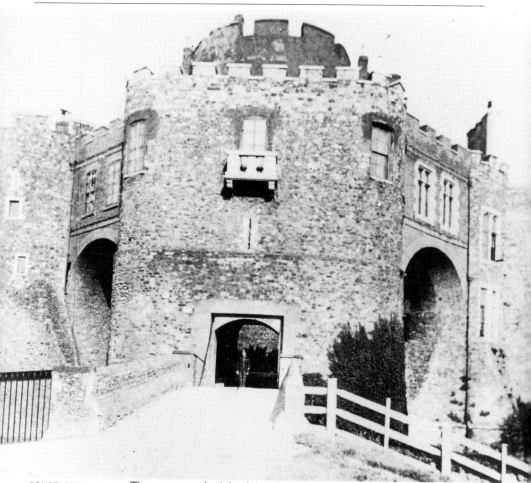

CONSTABLE'S TOWER. The tower was built by John de Fiennes whilst he was Constable of the Castle under William the Conqueror and for this reason it was known as Fiennes' Tower. Also known as Newgate the tower was enlarged in 1881. The tower as it is today contains, as its name suggests, the quarters of the Constable of the Castle, who is usually the commanding officer of the battalion stationed in Dover.

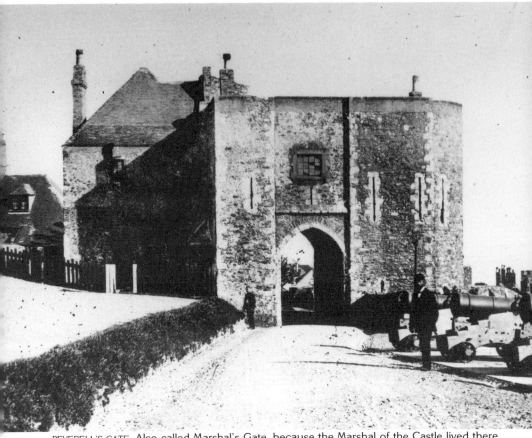

PEVERELL'S GATE. Also called Marshal's Gate, because the Marshal of the Castle lived there, Beauchamps Tower and Bell Tower, when it housed the bell to warn the garrison of attack. Built by Sir Geoffrey Peverell to guard the original approach from the south, it was strengthened when the semi-circular tower was added by Henry III.

ABOVE RIGHT:
DEBTORS PRISON. The Cinque Ports prison in Fulbert's Tower on the western outer wall was used as a general prison but was later used during civil unrest for political and religious prisoners, before becoming the Debtors and Smugglers prison. The charges were exorbitant and included 13s 8d on commitment, 2s 6d a week for lodging and £1 on discharge. The fate of those who could not pay is unknown, though the prisoners used to beg through a grill by dropping a box over the wall asking for pity on the debtors from passers-by and visitors to the castle. In 1855 the prison was closed, being demolished in 1911 to make way for new officers' quarters.

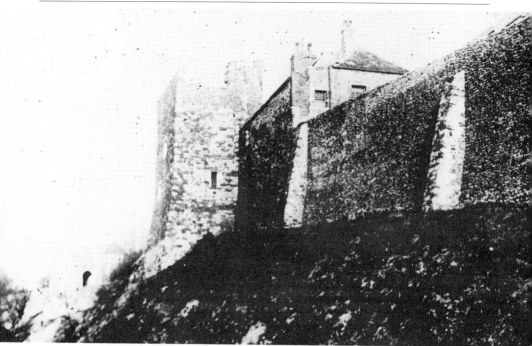

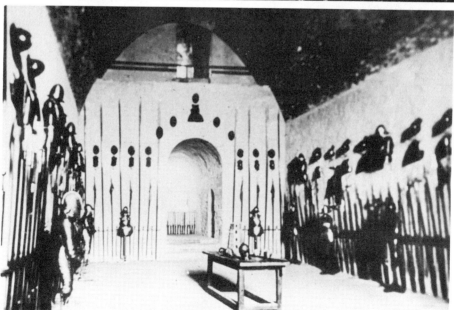

BANQUETING HALL. A display of armour in the Banqueting Hall. Above the doorway can be seen the Musicians Gallery from where the guests would be entertained.

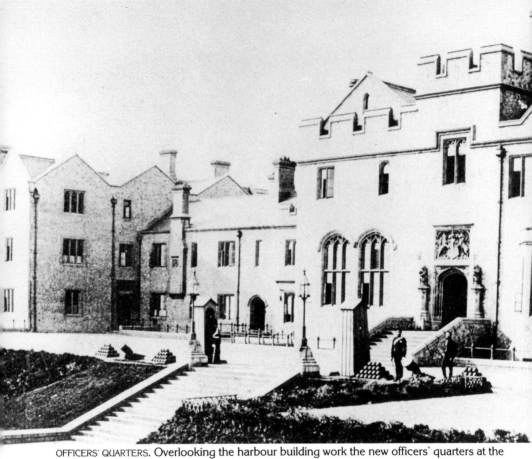

OFFICERS' QUARTERS. Overlooking the harbour building work the new officers' quarters at the
castle were built in 1857 and opened on 13 October 1858.

MOTE'S BULWARK. Henry VIII's Mote Bulwark was part of a series of bulwarks and batteries built to protect the seafront. Mote's bulwark is connected to the castle by a tunnel through the cliffs.

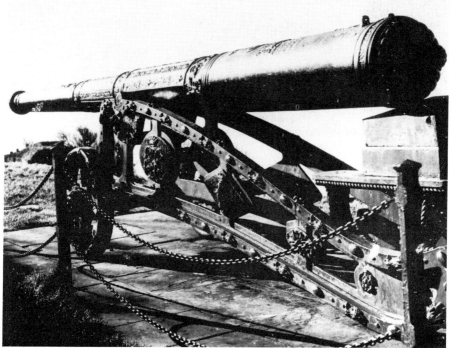

QUEEN ELIZABETH'S POCKET PISTOL. This 24ft.-long gun was presented by the States of Holland to Queen Elizabeth. The gun was cast in Utrecht in 1544.

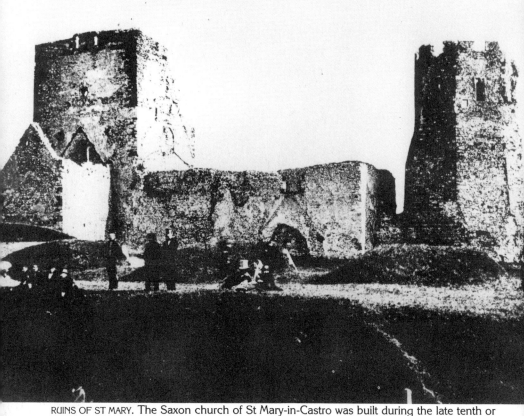

RUINS OF ST MARY. The Saxon church of St Mary-in-Castro was built during the late tenth or eleventh centuries. In 1690 public worship stopped, though soldiers' burials continued until they were moved to St James's and the church fell into decay. In 1780 the church was converted into a cooperage and a storehouse. In 1801 it collapsed but in 1808 enough remained for it to become a coal store.

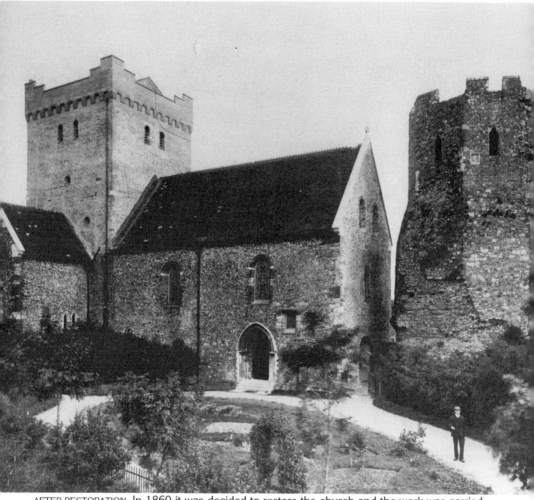

AFTER RESTORATION. In 1860 it was decided to restore the church and the work was carried out under the direction of Sir Gilbert Scott. St Mary-in-Castro was re-opened in 1862. Later restoration work was carried out by Butterfield in 1888 who completed the tower and added the vestry and the mosaic work in the nave.

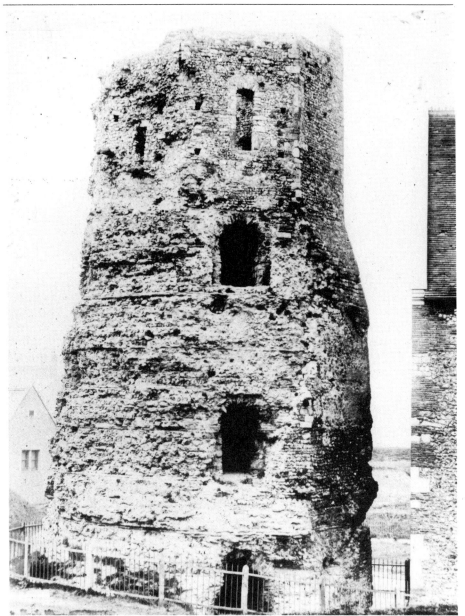

PHAROS. The oldest standing building in Dover. The pharos, a Roman lighthouse, stands on the cliff-top. It is estimated that it was originally much taller, up to a height of perhaps 80ft.

The Military Connection

Throughout history Dover has often had to live under the threat of invasion and consequently has been successively strengthened through the ages. While the castle remains the most obvious commitment to defence, Dover's military history is as varied and interesting as the times and the soldiers who have been based here.

The five miles of Napoleonic moats, ditches, bastions and batteries which lined the Western Heights, were described by William Cobbett in 1823 as 'Holes in the ground in which to hide Englishmen from Frenchmen'. In excess of a million bricks were used in the construction of the Drop Redoubt, a detached fort. Here there are the remains of a second Roman Lighthouse known as the Bredenstone. Below the Drop Redoubt is the site of the barracks, used to house thousands of soldiers until they were demolished in the 1960s.

It was here that an ingenious feat of military engineering and an interesting feature of Dover's military history was placed. The Grand Shaft is a unique triple spiral staircase through the cliffs, built to enable the quick movement of troops from the barracks to Snargate Street and the docks. Designed by Sir Thomas Hyde-Page, the 200-step, 140ft. staircase was begun in 1803 and completed in 1806 at a cost of £3,221 2s 10d and 3 farthings. During peacetime the three staircases were segregated by rank for 'Officers and their Ladies, Sergeants and their Wives and Ranks and their Women'. At Snargate Street there was a guardroom and cells for those too drunk or too late to climb the staircase. A bell was rung at 9 p.m. to warn soldiers of the closing of the staircase. In 1861, a member of the Royal Artillery Militia died in the barracks having just climbed the shaft. Fortunately he remains the only fatality from climbing the staircase, much to the relief of hundreds of visitors who have climbed the staircase since its re-opening to the public in 1981. On a lighter note, in 1812 a Mr Leith from Walmer rode his horse up the staircase for a wager.

Another feature of Dover is the gun turret built into the Admiralty Pier in order to defend the harbour from occupation. The twin 80-ton guns were set in a revolving turret and powered by two steam engines. Capable of firing 1700lb. shells, they were first fired in 1881 though they did not come into service until 1883. They were declared obsolete in 1902.

The first bomb dropped on England from an aircraft landed on Dover. At 11 a.m. on Christmas Eve 1914, Lieut. Von Prodzynsk dropped the bomb from his Taube aircraft. It fell in Mr Terson's garden in Leybourne Road, breaking a number of windows and blowing a man, who was cutting holly, out of a tree. Fortunately no one was killed. Members of the Anti Aircraft Corps collected the fragments and presented the mounted objects to the king.

During both world wars Dover's strategic importance led to it being singled out as a particular target. During the First World War the famous Dover Patrol, whose memorial at St Margaret's Bay was unveiled in 1921, had its headquarters here and operated along the coast performing mine-laying and mine-sweeping duties and checking on all shipping passing through the Channel. Dover's use as a naval base came to the fore, especially during such operations as the Zeebrugge Raid when eight VCs were won. The Zeebrugge Bell, taken from a Belgian church by the Germans who intended to use it to warn of British attacks on Zeebrugge, was given to Sir Roger Keyes by the King of Belgium. On St George's Day 'eight bells' are rung in memory of those who died during the raid.

Admiral Keyes also took the hardest decisions of all in Dover's long military history. The monitor, the Glatton, arrived in Dover in September 1918. On the 16th of the same month, while taking on ammunition, a massive explosion capsized the ship, trapping seamen below decks. Keyes rushed to Dover to assess the situation. Faced with the fact that the Glatton was a danger not only to the other ships in the harbour but also to the whole town, and with no chance of putting out the fire or flooding the ship, Keyes took the decision to destroy the ship to prevent further loss of life. After being towed outside the harbour, a destroyer, HMS Myngs, fired three torpedoes into the Glatton killing the trapped men who were still alive.

Dover's sturdy defences however, were to face a much greater test during the Second World War which inflicted even greater damage on the town.

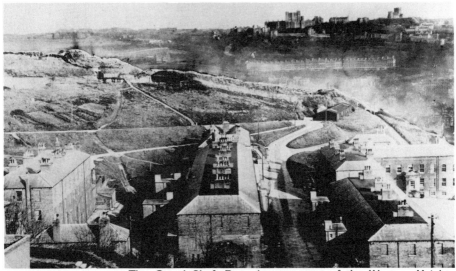

GRAND SHAFT BARRACKS. The Grand Shaft Barracks were part of the Western Heights fortifications which were finally completed under the recommendation of a Royal Commission of Defences in 1860 under Lord Palmerston. The Drop Redoubt, a detached fort, can be seen to the left. The Citadel and North Centre Bastion were linked to the Drop Redoubt by a series of moats and ditches as well as the Western Outworks and the South Front Barracks. The total cost was in the region of £280,000.

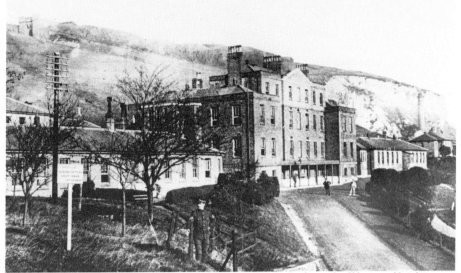

MILITARY HOSPITAL. The hospital, which overlooked the docks from the Western Heights, was built in 1803 and finally demolished during 1965.

OIL MILL BARRACKS in Snargate Street became barracks during the First World War and the cliff caves behind provided underground air-raid shelters for the local population. They were gutted by fire in 1965. *Circa* 1915.

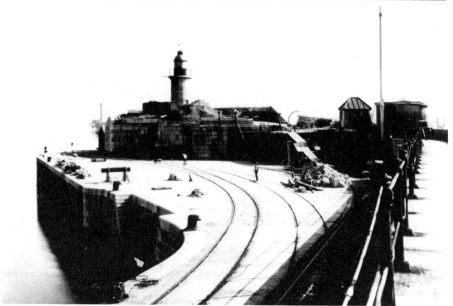

ADMIRALTY PIER GUN TURRET. The twin guns of the Admiralty Pier gun turret to the left of the lighthouse were first fired in 1881 but were not ready for service until 1883. In 1902 they were declared obsolete.

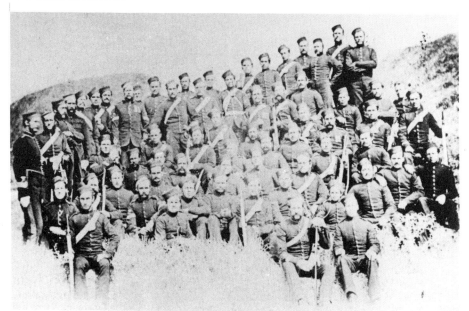

ROYAL ARTILLERY, DOVER 1863. Dover has been host to a great many soldiers. These are the officers of the Royal Artillery Militia in Dover in 1865.

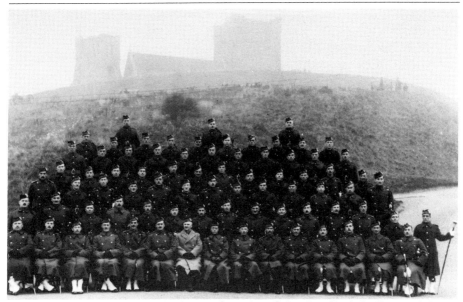

THE SEAFORTH HIGHLANDERS received a visit from their Colonel in Chief, the Prince of Wales, later Edward VIII (and Duke of Windsor), while stationed at the castle in 1924. St Mary-in-Castro is behind.

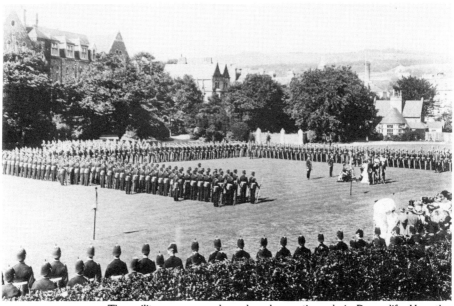

PRESENTING COLOURS. The military presence has played an active role in Dover life. Here the 1st Battalion Queen's Own Royal West Kent Regiment receives its colours in the grounds of Dover Priory.

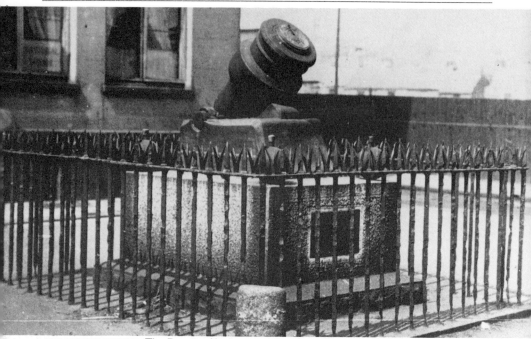

THE RUSSIAN MORTAR. The Russian Mortar was taken from Hango in 1855 by HMS *Blenheim*, during the Crimean War. A gift of Capt. W.H. Hall, the mortar was erected in Red Pump Square, which was renamed Blenheim Square. It was later moved to the corner of Liverpool Street where it stood in front of the Dover Patrol Hostel.

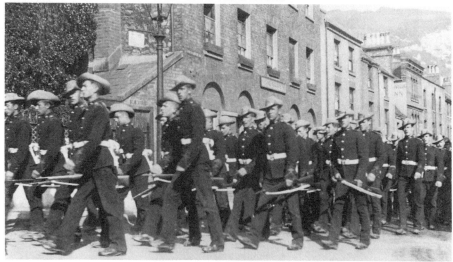

CANADIAN TROOPS. Dover has not only been host to British soldiers. Canadian soldiers, shown here, march past Limekiln Street on their way to Folkestone station, when the railway line was blocked by a cliff fall. 1915.

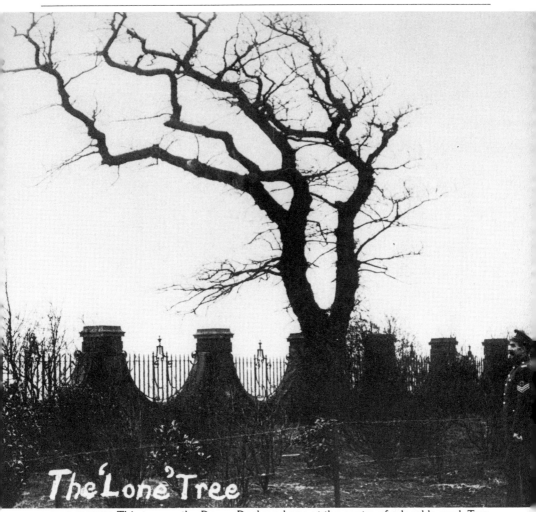

The 'Lone' Tree

THE LONE TREE. This tree on the Dover–Deal road was at the centre of a local legend. Two young officers at the castle fell in love with the same girl. One day, one of the officers named Donald was on guard duty when he saw the other with the girl. In a fit of temper he grabbed a heavy stick, set after the couple and attacked the officer, leaving him for dead. With the stick covered in blood, he pushed it into the ground amongst some bushes. The company left the next day without the injured officer, who could not remember the attack. On his return Donald, his personality changed by the event, felt compelled to return to the scene and there found a tree had grown from his stick.

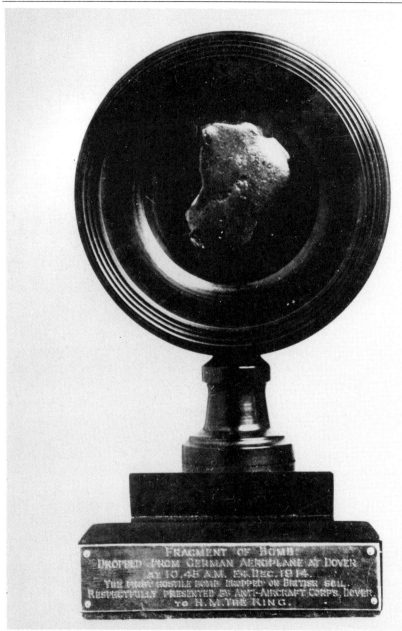

FRAGMENT OF BOMB
DROPPED FROM GERMAN AEROPLANE AT DOVER
AT 10.45 A.M. 24. DEC. 1914.
THE FIRST HOSTILE BOMB DROPPED ON BRITISH SOIL
RESPECTFULLY PRESENTED BY ANTI-AIRCRAFT CORPS, DOVER
TO H.M. THE KING.

THE FIRST BOMB DROPPED ON DOVER landed in Leybourne Road on Christmas Eve 1914, knocking a man from a holly tree. The fragments were later presented to the king by the AA Corps. This was the first bomb dropped on England from an aircraft.

HM DESTROYER *NUBIAN*. On 27 October 1916 the Destroyer HMS *Nubian* was hit in the bows by a bomb while its sister HMS *Zulu* was struck in the stern by a torpedo. The undamaged ends were then joined together to serve as HMS *Zubian*.

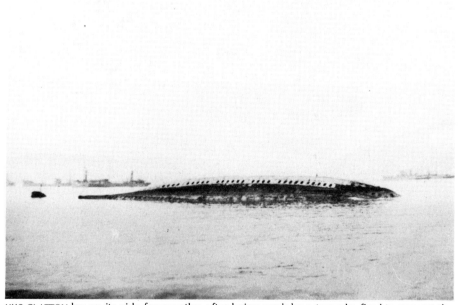

HMS *GLATTON* lay on its side for months, after being sunk by a torpedo, fired to prevent the ship, which was packed with explosives, from blowing up in the harbour whilst on fire. 1918.

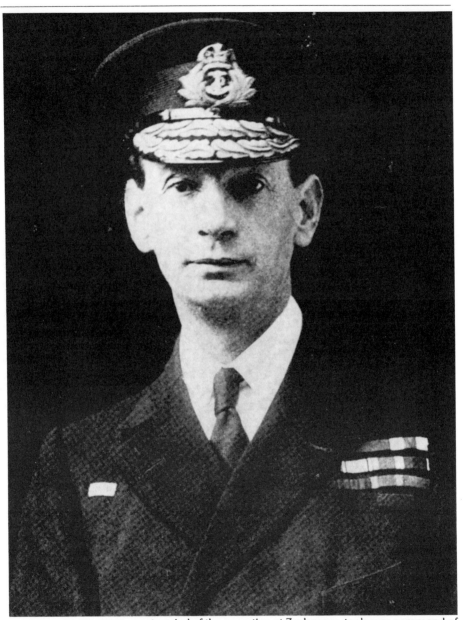

ADMIRAL SIR ROGER KEYES, mastermind of the operation at Zeebrugge, took over command of the Dover Patrol in January 1918. He died in 1945 and is buried in St James's Cemetery in Dover alongside those who died in the raid.

ZEEBRUGGE MOLE. On St George's Day, 1918, the Dover Patrol carried out one of the most audacious military operations ever. A double blow was planned against German forces on the Belgian coast; to block the entrance and exit of the Bruges Canal as well as the destruction of German destroyers at the Mole in Zeebrugge. To do this the batteries at Zeebrugge Mole had to be destroyed. This was done by Marines dropped from the *Vindictive*, who were then expected to destroy as much of the sheds, hangars and stores as possible before being rescued by smaller coastal motorboats and launches.

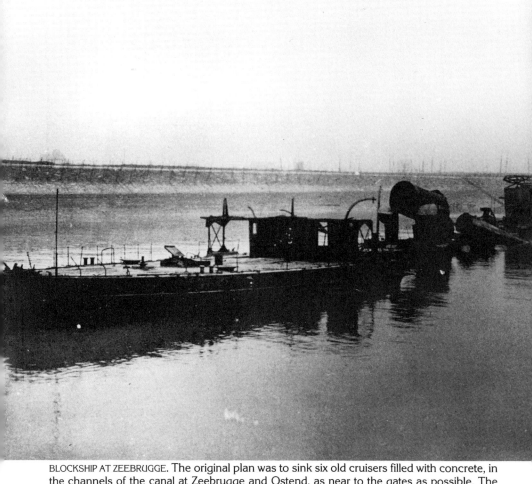

BLOCKSHIP AT ZEEBRUGGE. The original plan was to sink six old cruisers filled with concrete, in the channels of the canal at Zeebrugge and Ostend, as near to the gates as possible. The three blockships at Zeebrugge were *Thetis, Intrepid* and *Iphigenia*. Also involved were two old submarines, C-1 and C-3, which had been filled with high explosives. They forced their way among the piers and cross-tiers of the viaduct and, once there, were detonated. C-1 was delayed but C-3 completed the task successfully with more than 100ft. of the viaduct blown away. The sunken *Iphigenia*, shown here, lies in the canal.

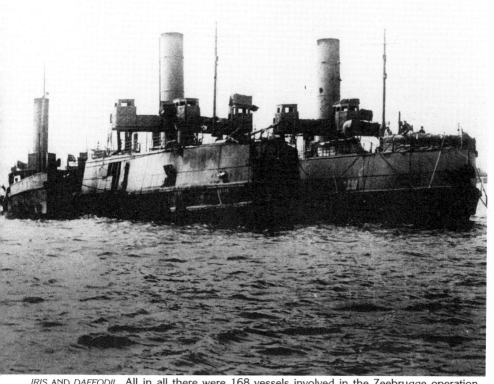

IRIS AND *DAFFODIL*. All in all there were 168 vessels involved in the Zeebrugge operation. Amongst them were two blunt-nosed Mersey ferries, *Iris* and *Daffodil*. It was the *Daffodil*'s duty to push the *Vindictive* onto the Mole and then, with *Iris*, to disembark marines onto it.

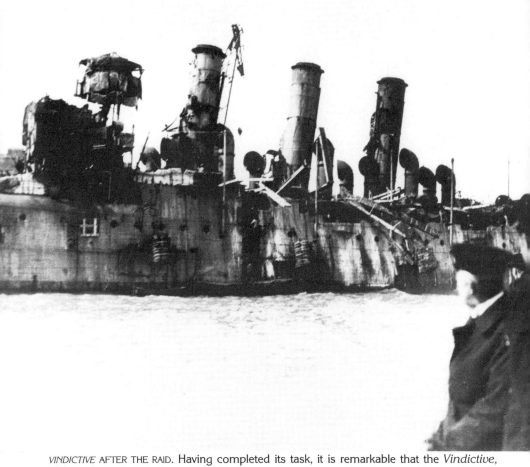

VINDICTIVE AFTER THE RAID. Having completed its task, it is remarkable that the *Vindictive*, albeit with a little help from *Daffodil*, managed to escape and make its way back to Dover, the whole raid having taken less than an hour. In total eight VCs were awarded for this action along with 20 DSOs and numerous other awards. The cost was heavy, 156 dead and nearly 400 wounded. Three weeks later the *Vindictive* was sent to Ostend where it was sunk across the entrance to Ostend Harbour. Raised after the war, it was hoped that *Vindictive* would return to Dover but the ship's back had been broken by the sinking and it was scrapped.

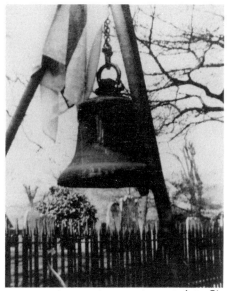

LEADING SEAMAN H.C. BEAUMONT was on board HMS *Myngs* during the Zeebrugge Raid. His diary and drawings are in the archives of the museum.

THE ZEEBRUGGE BELL was presented to Sir Roger Keyes by the King of Belgium and is now hung on a wooden cradle at the Town Hall. Every St George's Day 'Eight Bells' are sounded in memory of those who died on the raid. 1921.

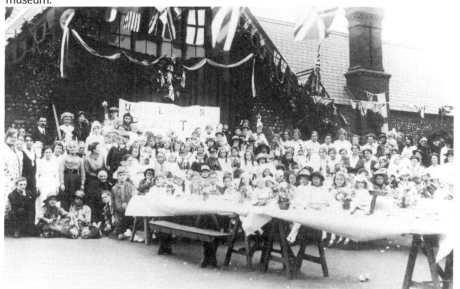

PEACE TREAT. A number of peace treats for the children were arranged at the end of the war. This one was held at Buckland School in London Road.

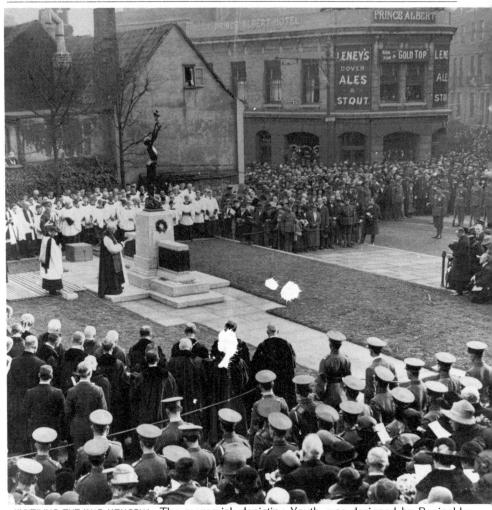

UNVEILING THE WAR MEMORIAL. The memorial, depicting Youth, was designed by Reginald Goulden and was unveiled by Sir Roger Keyes outside the library in 1924.

SECTION FIVE

Streets

The streets of Dover have seen many changes. The town's position during wartime has meant that many of the old streets have been destroyed and exist only in photographs. In those streets that have survived, buildings have been altered and in some cases removed altogether.

The increase in the ease of travel and in the level of traffic to the Continent also meant that many of Dover's old streets and buildings had to be demolished.

Much of the area surrounding the Western Docks, known as the Pier District, an almost self-contained town-within-a-town, had disappeared long before the demolition caused by the effects of wartime bombing and shelling.

New roads and railway lines meant that whatever stood in the way was removed, taking away much of the character of old Dover.

Many streets along the seafront and around the docks did not survive the years of shelling and bombing that were such a feature of Dover during the wars.

You would be hard pressed to recognise some of the old streets now. St James's Street, for instance, was a long, winding road, criss-crossed by many lanes and roads, running from Castle Hill and almost reaching the Market Square. Much of it is now a car-park.

From the Market Square the main thoroughfare of the town ran via Cannon Street, Biggin Street, High Street and London Road. In May 1893 a traffic survey confirmed this route through the centre of the town showing that 10,794 vehicles, carts, cycles, bathchairs and horses passed through Biggin Street. The four main users of the road at this time – pedestrians, cyclists, horse carriages and trams – can be seen using the street together in one of the photographs.

After the Second World War, Dover became a much-altered town. Many roads, partly because of their narrow nature, disappeared, removing a great deal of the pre-war character of narrow alleyways and thoroughfares. If you look closely you may be able to discover these streets for yourself.

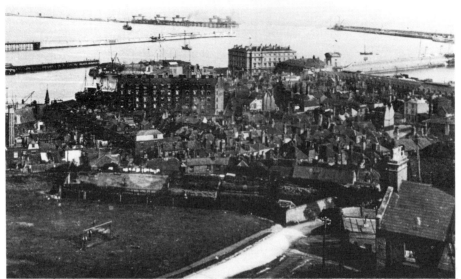

PIER DISTRICT FROM WESTERN HEIGHTS. The Pier District was the name given to the collection of small narrrow streets around the Western Docks which survived, like a town-within-a-town, until mostly demolished during the 1950s. *Circa* 1900.

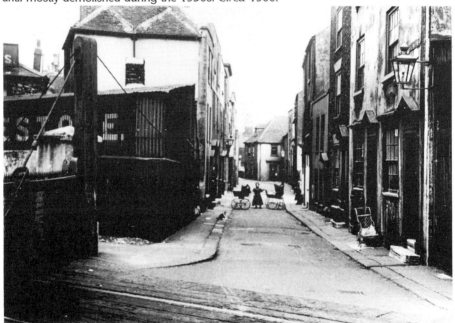

NO. 7 STAR STREET from the Dover to Folkestone railway, looking towards Clarence Place. From its origins this narrow thoroughfare at the back of Beach Street was closely associated with the mariners' quarters. *Circa* 1900.

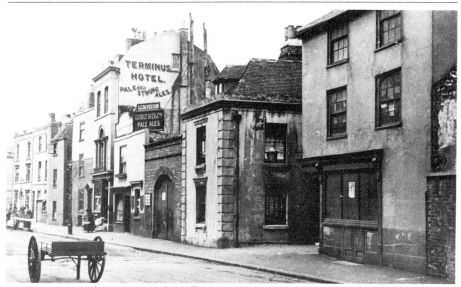

BEACH STREET. At the eastern end, the Terminus Hotel (demolished 1962) offered strong and pale ales, while next door G.C. Deverson of the Brussels Inn offered George Beer & Co.'s fine ales. *Circa* 1900.

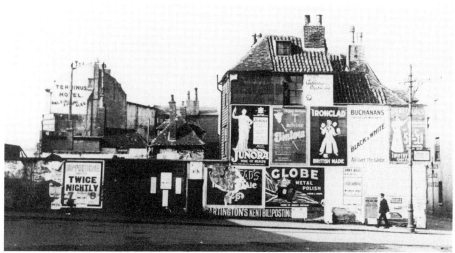

PARTINGTON'S WALL ADVERTISEMENTS were a striking feature of the Pier District situated between Beach Street and Seven Star Street. Among the adverts is one for the Hippodrome Theatre in Snargate Street.

SNARGATE STREET from the corner of Snargate Street and Blenheim Square. Between 1928 and 1930 this road was widened. It is hard to imagine the present Snargate Street like this.

SNARGATE STREET AND NORTHAMPTON STREET. At the corner of Snargate Street is The Clarendon Hotel, demolished in 1950 along with the rest of Northampton Street including, to the right, the Dover Sailors' Society.

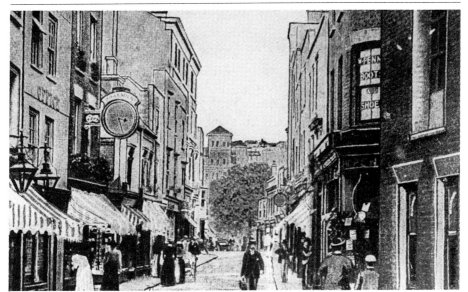

SNARGATE STREET. To the left is the post office and next door is Igglesden's bakery. Igglesden's clock had been removed from above the road in 1908. Opposite is the shoe shop of W. Penn. *Circa* 1910.

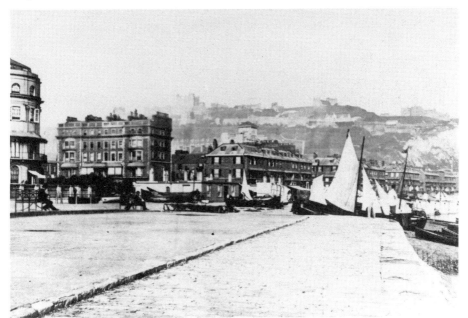

MARINE PARADE. A view along the promenade of Marine Parade. The detached building to the left is Wellesley Terrace which was redeveloped in 1893 and renamed The Grand Hotel. *Circa* 1890.

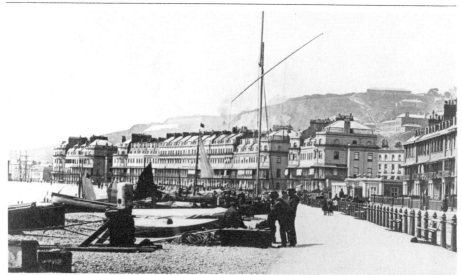

WATERLOO CRESCENT. Built in 1834, these elegant seafront buildings now house the White Cliffs Hotel, while those to the left are the offices of the Dover Harbour Board. The Western Heights fortifications can be seen in the background.

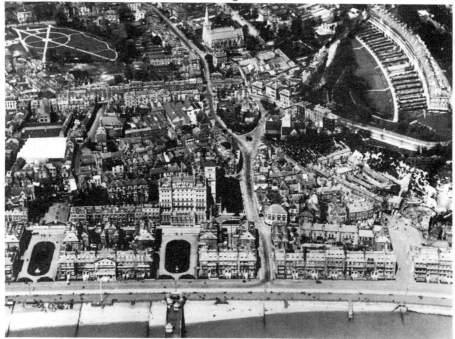

AERIAL VIEW OF THE SEAFRONT showing Guildford and Clarence lawns. To the right are the remains of the old gasworks in Trevanion Street. Most of the seafront which can be seen here was demolished due to war damage. *Circa* 1926.

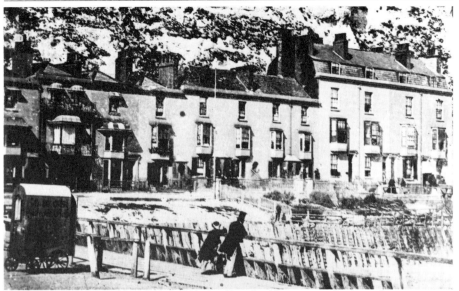

ATHOL TERRACE. Located at the end of Marine Parade, this now stands above the entrance to the Eastern Docks. The wagon of Amos, the photographer, can be seen in the foreground and that could be him standing at the railings. *Circa* 1870.

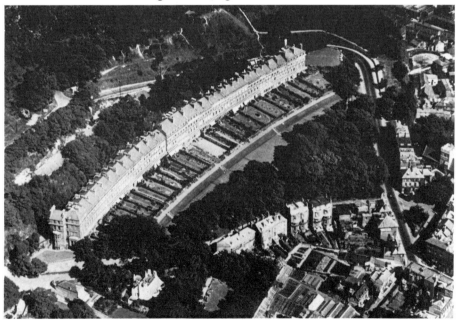

VICTORIA PARK FROM THE AIR. These houses were built in 1864 and described at the time as 'suitable for the residences of Military, Naval and other Gentlemen'. Many have since become bedsits and flats. *Circa* 1926.

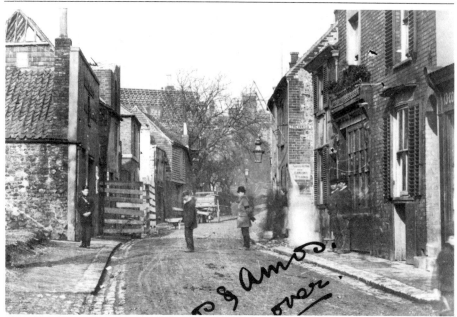

WOOLCOMBER STREET was partially demolished for widening in 1895. At the corner of Trevanion Street was Marsh the butchers. Undergoing demolition was the shop of J. Broad, confectioner and refreshment contractor, who also owned No. 13.

ST JAMES'S STREET. At the corner of St James's Street and St James's Lane was the general store of A. Wylde. Behind the hoarding on the right is the Old Town Mill demolished in 1956. 1925.

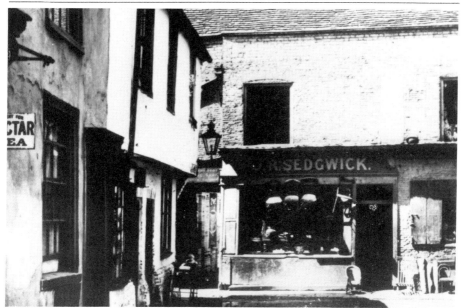

ST JAMES'S LANE. James R. Sedgwick was a furniture broker at the corner of St James's Lane and Flying Horse Lane. 1925.

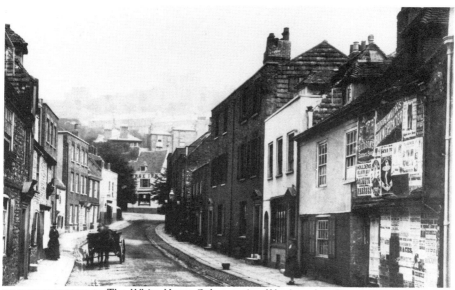

ST JAMES'S STREET to The White Horse Pub crossing Woolcomber Street. The three-storey building on the left corner still remains. The road was widened in 1894 and much demolished after damage during the Second World War. It is now a car-park. *Circa* 1893.

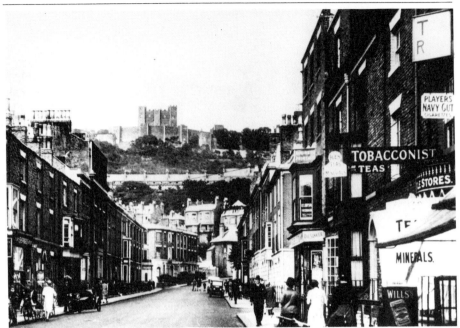

CASTLE STREET, built in 1897, runs parallel with St James's Street, connecting Castle Hill to Market Square. It became, and still remains, popular with professional people, lawyers in particular. *Circa* 1930.

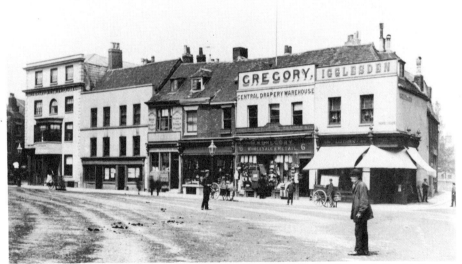

MARKET SQUARE. Igglesden's Restaurant was mentioned in Dickens's novel, *David Copperfield*. The Garrick Inn (centre) was demolished in 1905.

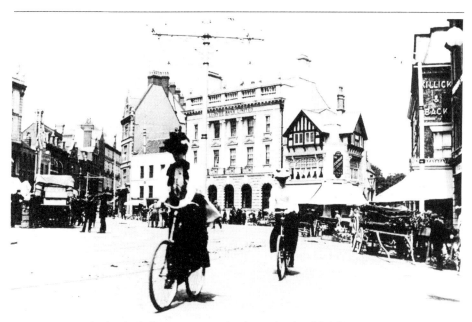

MARKET SQUARE. Igglesden's Restaurant received a major facelift following the demolition of the City of Antwerp Hotel, and Lloyds Bank replaced the Garrick's Head. Killick and Back, a drapers, stood at the corner of Market Square and Dolphin Lane. *Circa* 1905.

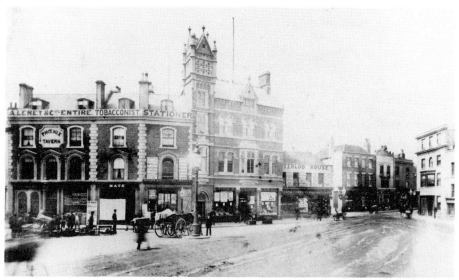

MARKET SQUARE c. 1897. The Phoenix Tavern and Alhambra Music Hall were destroyed by fire and are now Barclays Bank. India & China Tea Stores, Bone's Library and the central registry office are now the NatWest Bank. Waterloo House, occupied by Mart & Co., clothiers, has been demolished.

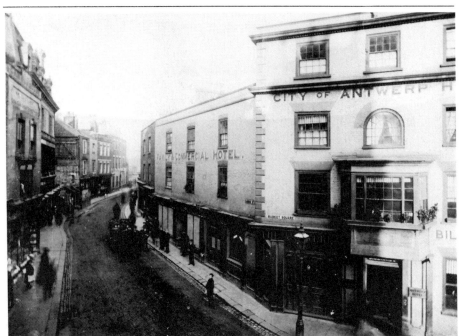

CANNON STREET from Market Square, looking towards Biggin Street, prior to widening (including the demolition of the City of Antwerp Hotel on the right) in 1893.

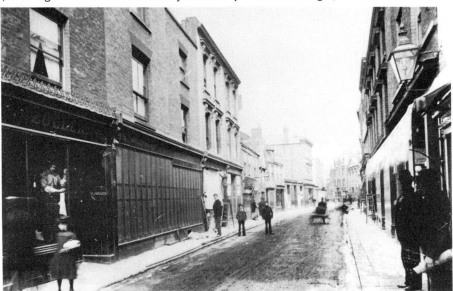

BIGGIN STREET in 1895. No. 44, H. Zoller, was a pork butcher's shop and next door was G. Hatton's millinery shop. In the distance can be seen the Salem Chapel, now Boots the chemists. W.J. Barnes, the chemist, was at No. 54.

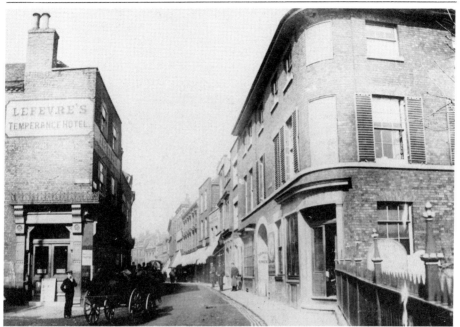

BIGGIN STREET looking towards High Street from St Mary's Church. Lefevre's Temperance Hotel and Coffee Tavern is opposite The Wellington Hotel (demolished 1961) which until recently was Tescos supermarket.

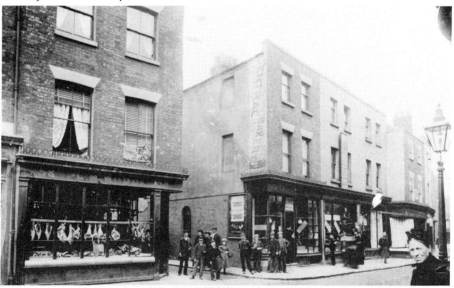

WORTHINGTON LANE was demolished in 1895 for widening and was re-named Worthington Street. C.M. Wood's butcher's shop was demolished and moved to the corner opposite. Posters on the bakery windows announce the details.

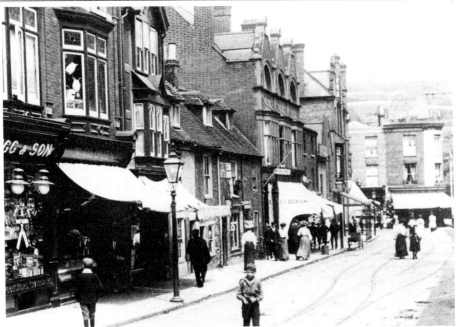

WORTHINGTON STREET looking towards Biggin Street and a canopied building, now the Midland Bank. To the left is Grigg's and Sons, a stationery firm. E.F. Bockham, a tool merchants, was later occupied by Woolworths. 1925.

PRIORY STREET. The corner of Priory Street and Biggin Street. Scott and Sons, a dry cleaners, was demolished and was replaced by the General Post Office in 1875.

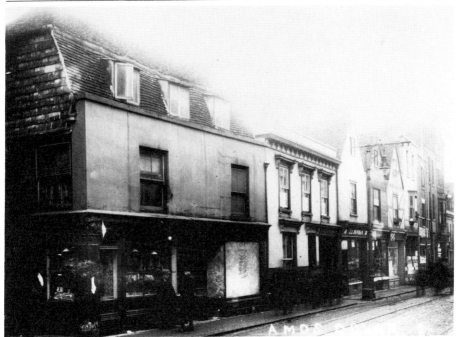

BIGGIN STREET. Third from the left is J.J. Bowman's a hairdresser's shop at No. 68 Biggin Street, where MacDonalds stands today. 1875.

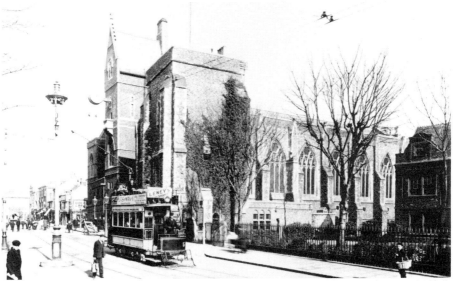

HIGH STREET FROM THE PRINCE ALBERT PUB, C. 1900, showing Maison Dieu and Connaught Hall. The building to the right is Maison Dieu House. Once a private house, it became the public library in 1952.

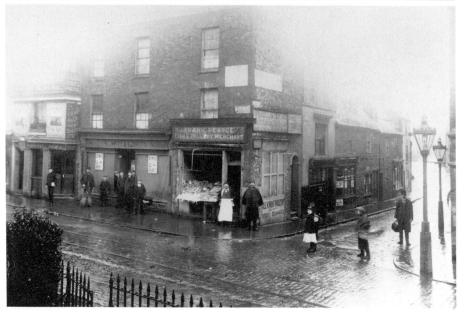

HIGH STREET AND LADYWELL. Ladywell before widening in 1903. On the corner is F. Pearce, poultry merchants, the owner of which is probably the man in the apron outside the shop. The Devonshire Arms (1871–1902) is to the left.

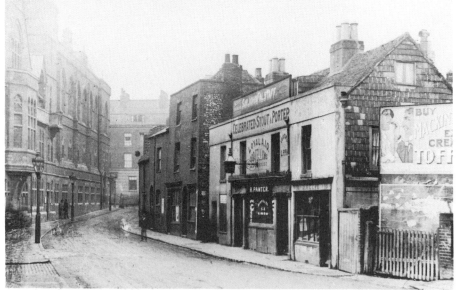

LADYWELL. During the 1903 widening the buildings on the left were demolished. The 'Sir John Falstaff' (E. Painter) was rebuilt that year, while the shop on the corner was rebuilt in 1907, it is now being Scott's chemists.

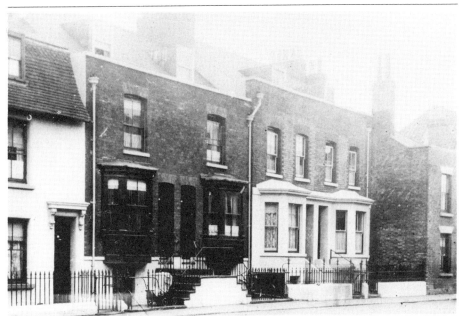

ALMA STREET, opposite the Grapes (now Louis Armstrong) pub, in Maison Dieu Road (formerly known as Charlton Back Road) was built in 1869. 1935.

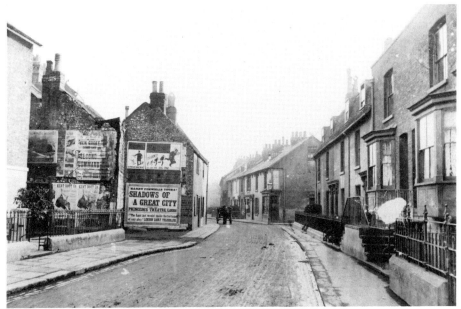

MAISON DIEU ROAD (formerly known as Charlton Back Road) was widened in 1893. The buildings to the left are now the Charlton Green postal sorting office; those to the right are the Dover Engineering Works with Peter Street at the corner. *Circa* 1902.

COLEBRAN STREET was demolished, along with Peter Street and Branch Street, in 1935 to make way for the expansion of the Dover Engineering Works.

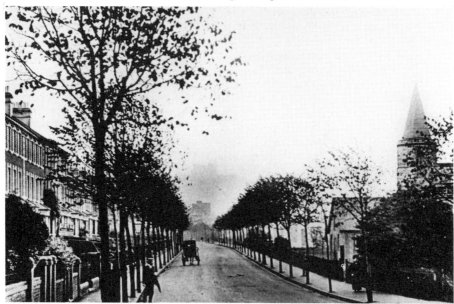

BARTON ROAD FROM CHERRY TREE AVENUE looking towards the castle. To the right is St Barnabas's Church which was built in 1902 and used until 1953 when it was rendered redundant and demolished.

SECTION SIX

Buildings

The Maison Dieu is one of the most recognisable buildings in Dover. Its medieval origins are clearly identifiable against the imposing Victorian architecture of the adjoining Connaught Hall, added after the removal of the old town gaol.

The Maison Dieu and the successive alterations adjoining it have served many purposes. The original pilgrim's rest and hospital, caring for pilgrims as well as wounded and destitute soldiers and old people, had a fourteenth-century square tower added to it.

By 1534, the Maison Dieu had become a large and wealthy religious establishment with stables, barns, a brewhouse and extensive farmlands. In 1534 the Master and brethren signed the Oath of Supremacy of Henry VIII and all religious connections of the Maison Dieu ceased when it was surrendered to the Crown for use as a naval storehouse, becoming a critical supply base for the fleet at the time of the Armada.

In 1834 the Maison Dieu estate was sold and Lot 1, the Maison Dieu forge and carpenter's and plumber's shops and cottages, was bought by the council. The Maison Dieu House, built in 1665, was a private residence until it was bought by the council and eventually became the public library in 1952.

In 1836 the gaol was built to replace the old gaol in the Market Square. In 1859, after many false starts, restoration work under Ambrose Poynter and William Burges commenced in the Stone Hall of the Maison Dieu. Both admired and incorporated many medieval motifs and designs into the work which was completed in 1863. In 1877 the gaol was closed and in 1881 replaced, despite local opposition, by the Connaught Hall, which was designed by William Burges as a concert hall and meeting place.

Maison Dieu House, built alongside the naval storehouse, was for many years the Victualler's House and it is not surprising that for a town built upon the livelihoods of seafarers and soldiers, Dover had more than its fair share of public houses. Indeed at one time there were 365 of them. Many of them basked in extraordinary names such as the Cause is Altered, the Friend in Need, the Who'd o' Thought It and the Why Not. With so many public houses in the town, competition amongst local breweries was fierce and plentiful.

Dover also boasted a large mill industry with six mills operating in Dover, including the Crabble Corn Mill of the Mannering Family, Buckland Paper Mill, the Charlton Mills and the old oil mills in Snargate Street.

As Dover's wealth and importance grew, so the town began to expand beyond the limits of the old town. Many road-widening schemes became necessary. Since then, in some parts only the names of the shops have changed, in others whole streets have disappeared. But once again war was to alter the face of Dover more quickly than the need for expansion.

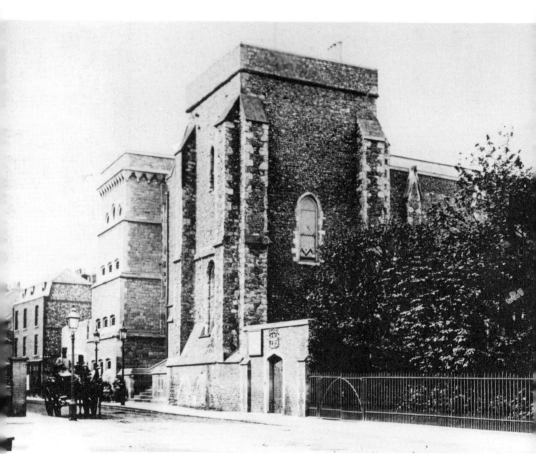

MAISON DIEU AND GAOL. In 1867 the prison was built below and to one side of the Maison Dieu, the chapel of which became a courtroom. The Prisons Act of 1877 closed down the prison and its upper floors were demolished and rebuilt to house the Connaught Hall.

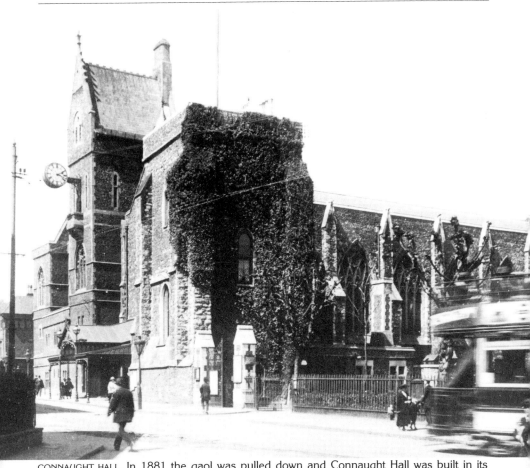

CONNAUGHT HALL. In 1881 the gaol was pulled down and Connaught Hall was built in its place, adjacent to the Maison Dieu, as a meeting room and concert hall for the town. It also contains the rooms used by the Mayor and the Charter Trustees. The interior was designed by William Burges though completed after his death.

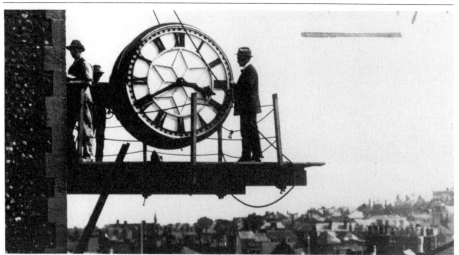

THE TOWN HALL CLOCK, affectionately known as 'Ye Olde Frying Pan', shown here undergoing repairs and restoration in 1924.

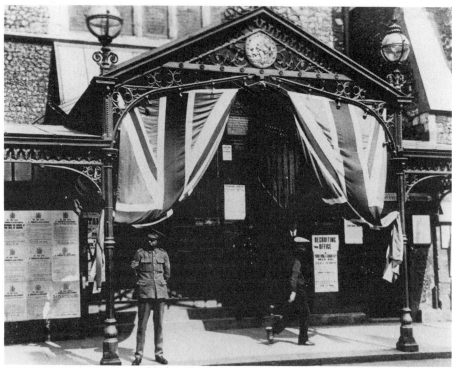

THE TOWN HALL PORCH was added to the entrance along with two lamps. During the First World War, when this picture was taken, the Town Hall was used as a recruitment centre. The porch was removed for the war effort during the Second World War. *Circa* 1916.

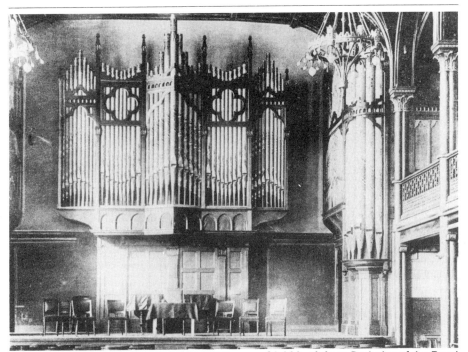

THE TOWN HALL ORGAN in the Connaught Hall was a £3,000 gift from Dr Astley of the Royal Victoria Hospital. The interior of the hall was designed by William Burges, though completed after his death.

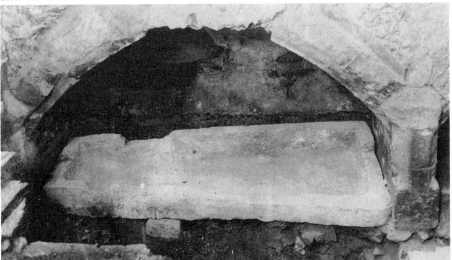

COFFIN. In 1927, during repairs on the south side of the great hall, local workmen discovered a stone coffin, measuring over 7ft. in length. The skull, pelvis and bones inside were mixed with fragments of medieval tiles and iron nails.

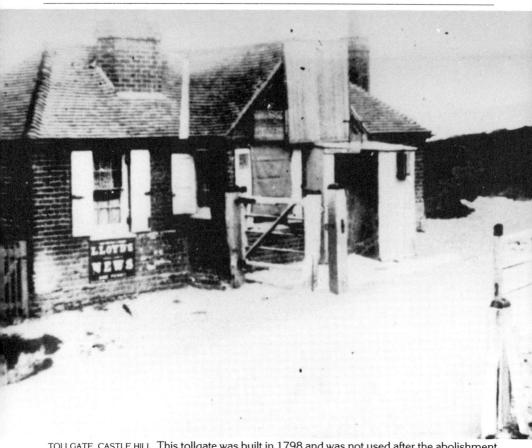

TOLLGATE, CASTLE HILL. This tollgate was built in 1798 and was not used after the abolishment of tolls in 1862. At the time of this photograph the keeper was Thomas Munn.

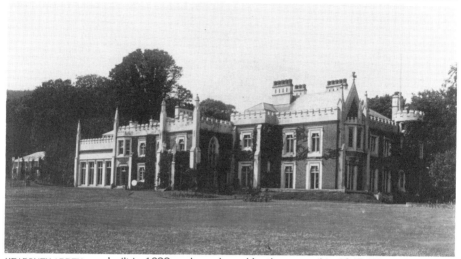

KEARSNEY ABBEY was built in 1822 and purchased by the council in 1945. When dry rot was discovered the building was demolished and the grounds became a park. Only the small wing to the left survived as a café.

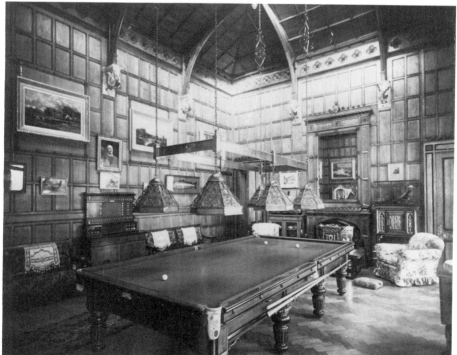

BILLIARD ROOM, KEARSNEY ABBEY. The oak-panelled interior has a tiled fireplace, with a massive oak chimneypiece supported by a Gothic arch of marble.

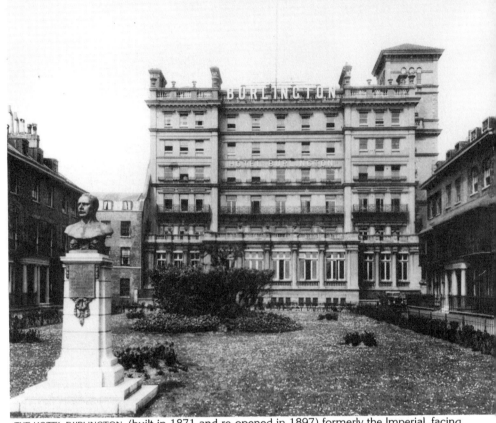

THE HOTEL BURLINGTON, (built in 1871 and re-opened in 1897) formerly the Imperial, facing Clarence Lawn, was a familiar sight near the seafront. Its distinctive appearance meant that it was used as a sight mark for German gunners during the Second World War and, like much of the area, was too badly damaged to be repaired, it being demolished in 1949.

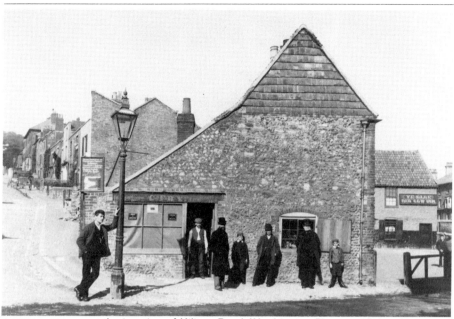

C. FRY'S DAIRY was at the junction of Military Road, Worthington Place and Priory Place, and sold lemonade, soda and ginger beer. To the right is Ye Old Red Cow public house which was demolished in 1971.

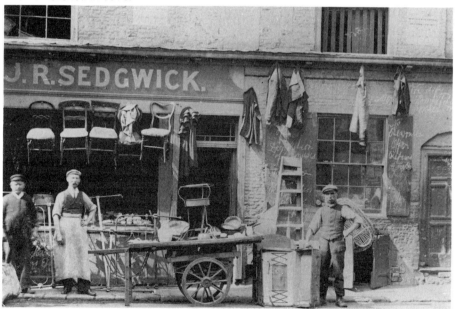

J.R. SEDGWICK'S. James Sedgwick was a furniture broker at the corner of St James's Lane and Flying Horse Lane. He can be seen standing on the right outside the shop.

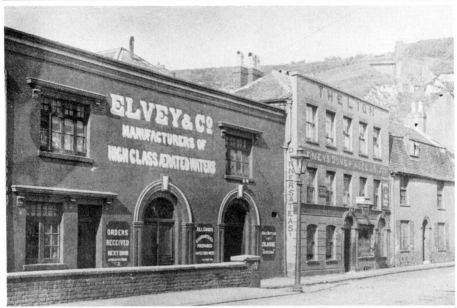

ELVEY & CO., 'Manufacturers of High Class Aerated Waters', in Elizabeth Street, was one of three such firms in the street. Meanwhile next door, the Lion (J. Proud, landlord) offered Leney's Dover Ales. *Circa* 1900.

CHARLTON FLOUR MILLS, built in 1840, across the bridge at the junction of Bridge Street and Maison Dieu Road. The tower in the centre was a water reservoir for the sprinkler system at the mill. 1922.

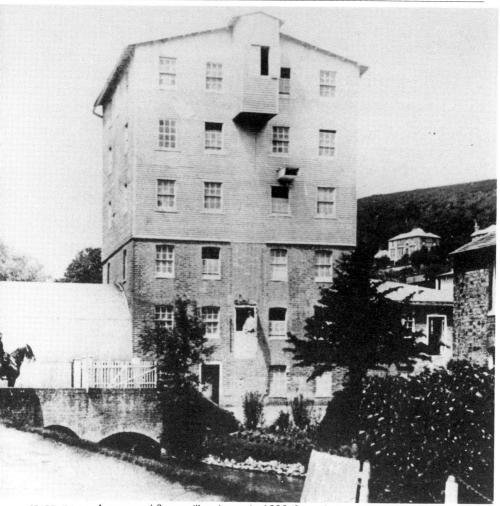

CRABBLE MILL. A corn and flour mill as it was in 1890, from the road. For many years it was owned by the Mannering family who purchased the mill in 1863. The mill was renovated by the district council and has since passed to an independent trust.

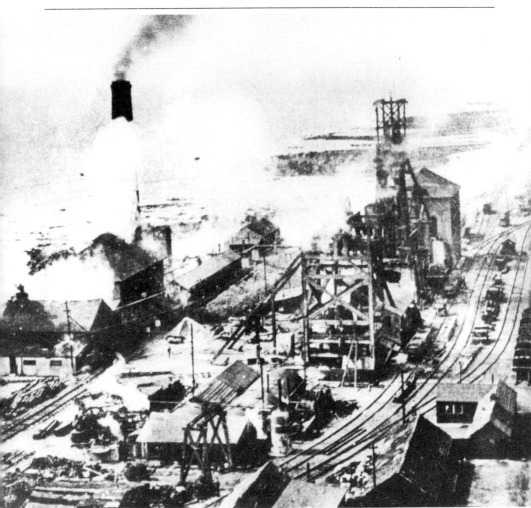

DOVER COALFIELD. Coal was discovered at a depth of 1,100ft. in February 1890 using the abandoned Channel Tunnel workings of 1880. In 1896 the sinking of Brady Pit was begun. The train which carried the men to work was known as the 'Klondike Express'. The colliery's history was an uncertain one, it changing hands several times, while flooding was a consistent problem for all three shafts. In one case over 54,000 gallons per hour needed to be removed. In March 1897 eight men drowned in an inrush of water in Brady Pit. The colliery finally closed in 1915 and was dismantled and sold.

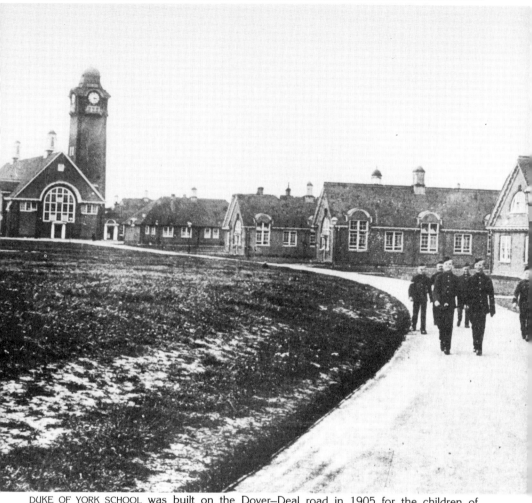

DUKE OF YORK SCHOOL was built on the Dover–Deal road in 1905 for the children of servicemen, reflected in the style of uniform of the time. *Circa* 1910.

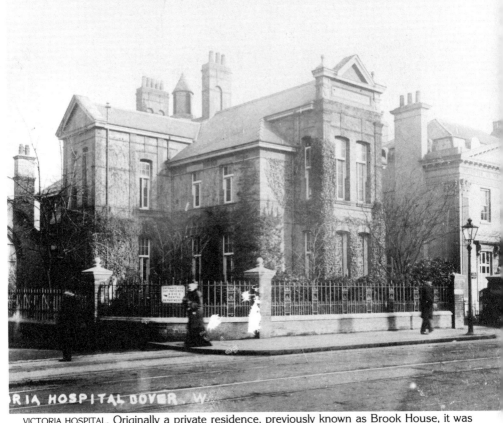

VICTORIA HOSPITAL. Originally a private residence, previously known as Brook House, it was bought for £1,336 from a fund set up in thanksgiving for avoiding the cholera epidemic of 1850. The hospital opened in 1851. A new wing built from public subscription was later added as a permanent memorial to Queen Victoria. The hospital finally closed in November 1987.

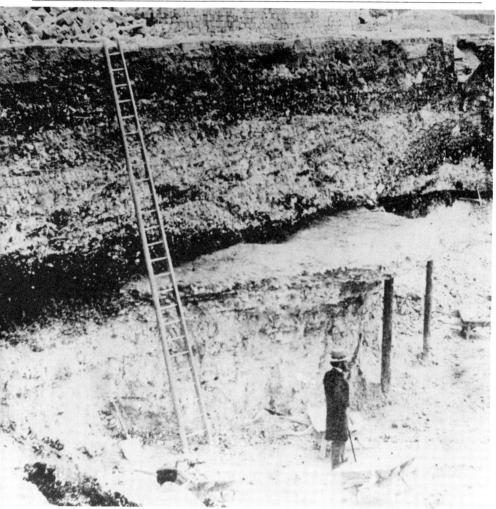

THE FOUNDATIONS OF THE SECOND PHAROS were excavated in 1861 during the building of the Drop Redoubt on the Western Heights. The archaeologist in charge, Clement Tate, is the man standing in the foreground. The remains have been known as the Bredenstone and as 'the Devil's Drop of Mortar'.

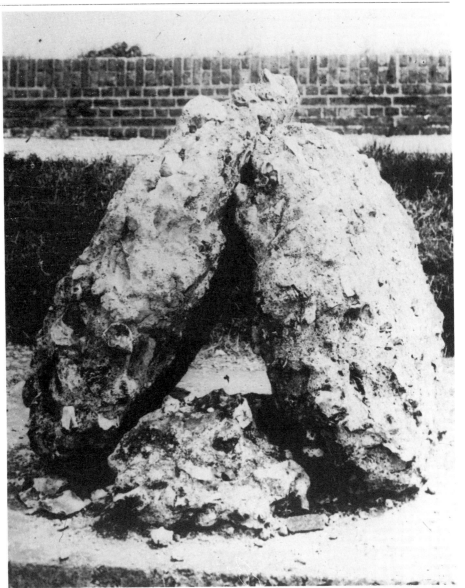

THE BREDENSTONE, the remains of the second Roman pharos, are now protected in the Drop Redoubt and were once an integral part in the installation ceremony of the Lord Warden of the Cinque Ports. *Circa* 1870.

SECTION SEVEN

Churches

Rapidly following Dover's military and commercial heritage in importance is Dover's ecclesiastical history.

With the Maison Dieu, which was originally built as a pilgrims' rest and hospital, Dover became a natural place for pilgrims from the Continent to prepare for their journey. Three properties around Dover were equally important; the Priory which has given its name to the main railway station and many streets around Dover; the earlier Priory of St Martin-Le-Grand near the Market Square; and St Radigund's Abbey.

The Priory was founded, with a great deal of political manoeuvering in 1135 by the Archbishop of Canterbury, Archbishop Corbeil, who died shortly afterwards.

Originally intended for the Austin Canons of Merton (of whom Archbishop Corbeil had once been the Prior), a dispute broke out between Corbeil and the Bishops of Norwich and St Davids. Corbeil died shortly after. The monks of St Martin-Le-Grand Priory (whose own priory was removed in 1159) took control before being ousted by the Benedictine monks of Christ Church, Canterbury. The Priory's history has been a troubled one. King Stephen is said to have died there. Thomas de la Hale was murdered here when the French raided and burnt the town in 1295. Its fortunes declined and for many years it was a farm. In 1863 one visitor, Mr John Seddon, was prompted to remark on his 'disgust at such foul desecration' of the site. In 1879 it was taken over by the Dover College which still controls the site today.

From its humble beginnings, St Mary's Church in Biggin Street, closed by the Reformation, became increasingly important after it was restored by public request. It became the place for elections between 1585 and 1826 and today remains the main place of worship in Dover.

The Church of St Paul at Charlton alongside the river was a rebuild of an earlier church which dated from before 1291. Having been rebuilt in 1827, the small church was replaced by the larger church of St Peter and St Paul in 1893. The new church cost £12,000 and was built by J.J. Wise of Deal from the plans of J. Brooks. Shortly after the new church was completed the old church was demolished.

The Church of St James was the oldest church in Dover and had the greatest role to play in the traditions of Dover. It was here in the church in St James's Street that the Cinque Port Court of Admiralty and Chancery held its sessions.

Churches, it seems, were not immune to the effects of war, perhaps because of their pronounced appearance. Many of the churches shown here were

damaged by shelling and bombing during the Second World War and, ironically, both St James's churches, only a couple of hundred yards apart, were destroyed.

Following the war many churches, faced with declining numbers, became redundant and were subsequently demolished as was the fate of Christ Church in Folkestone Road, St Barnabas's in Barton Road and St Bartholomew's in Templar Street.

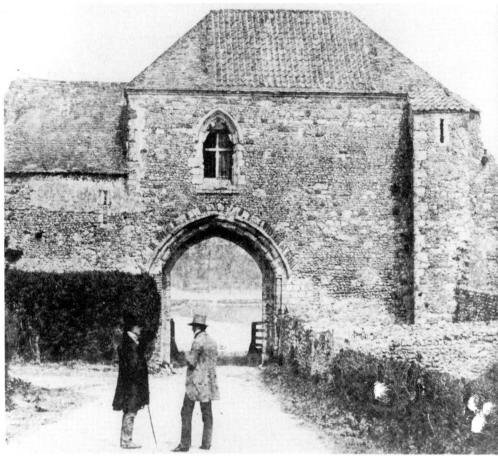

GATEWAY, DOVER PRIORY. The Priory was founded in 1135 by Archbishop of Canterbury Corbeil, intending that the Austin Canons of Merton should occupy it. The monks of Christ Church opposed this. A clerical dispute took place between the bishops of Norwich and St Davids and Corbeil, who died 11 days later. The monks of St Martin's in Dover took possession but were later ousted by Benedictine Monks of Christ Church, Canterbury. The gateway was restored in 1882 by public subscription as a testimonial to Sir Richard Dickeson, Mayor of Dover. When the Priory was taken over by the Dover College, it became its library.

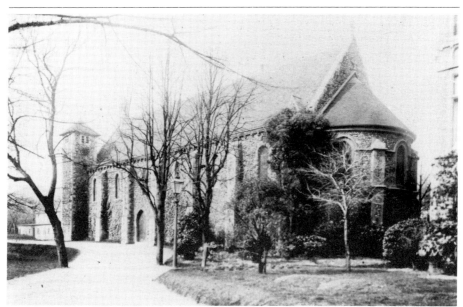

THE GREAT HALL, DOVER PRIORY. The Great Hall is now the school chapel of the Dover College, which took over the Priory in 1879.

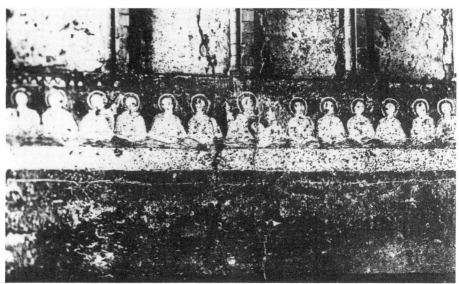

FRESCO, DOVER PRIORY. The interior of the Refectory includes this fresco which was nearly whitewashed over by workmen during the restoration of the Priory.

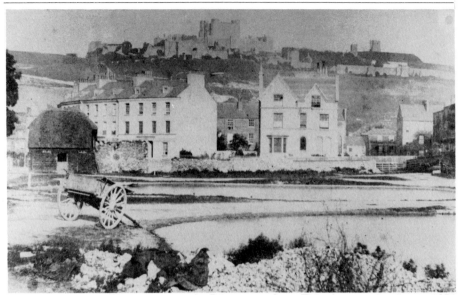

THE PRIORY AS A FARM. For many years the Priory was a farm. This photograph, taken in 1851 by George Shepherd, shows Effingham Crescent and the view to the castle.

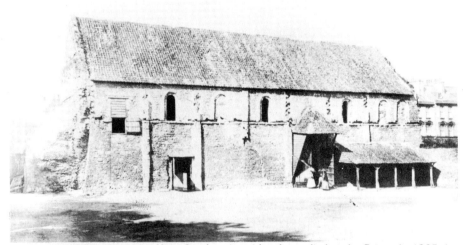

THE REFECTORY, DOVER PRIORY. King Stephen is said to have died at the Priory. In 1295 the Priory was burnt by the French and in the raid Thomas de la Hale was killed. This is the Refectory photographed from what is now Effingham Street. *Circa* 1870.

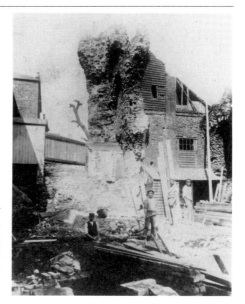

RUINS OF ST MARTIN-LE-GRAND. The ruins of the Priory of St Martin-Le-Grand. The monastery was removed in 1159 and desecrated in 1528. The church was partially restored before the ruins were finally removed in 1892. The site is now occupied by the NatWest Bank in Market Square.

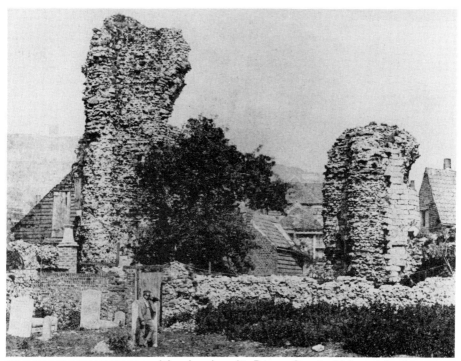

RUINS OF ST MARTIN-LE-GRAND and the churchyard in Princes Street, which contained the grave of a poet, Charles Churchill. The graves were later removed to Cowgate Cemetery.

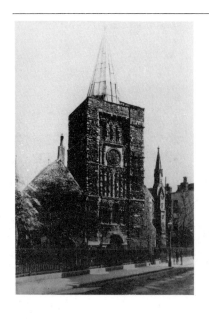

ST MARY'S FROM CANNON STREET. Closed in 1536 during the Reformation, it was re-opened at public request. Elections were held there between 1585 and 1826. Rebuilt in 1843, the tower was again restored in 1897, the church becoming the main place of worship in Dover.

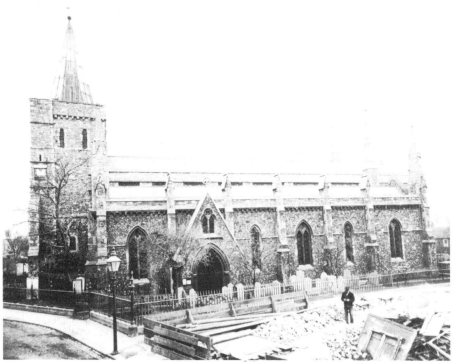

ST MARY'S from Cannon Street after the removal of Sladden's from the south.

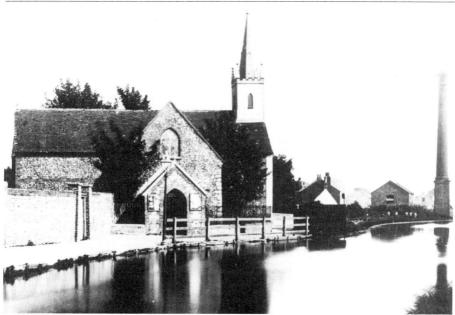

OLD CHARLTON CHURCH OF ST PETER was rebuilt in 1827 on the site of an earlier church alongside the River Dour. *Circa* 1870.

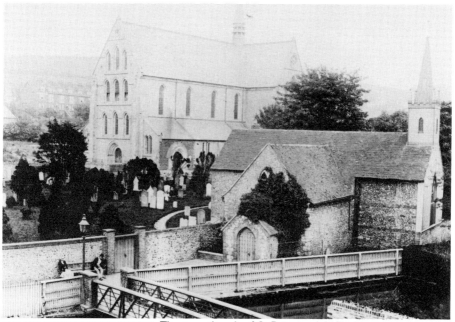

OLD AND NEW CHARLTON CHURCH. The new church of St Peter and St Paul replaced the older church of St Peter, which was demolished shortly after the new church opened in 1893.

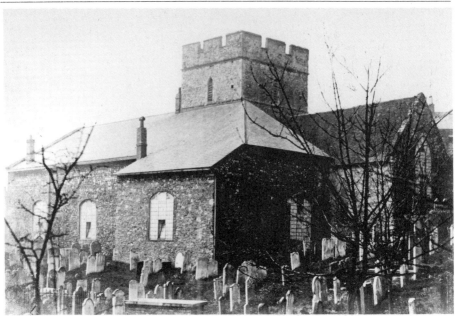

OLD ST JAMES'S CHURCH is the oldest church in Dover, dating back to 1291, though the wings are later additions. The Cinque Port Courts of Chancery and Admiralty were held in the South chapel. *Circa* 1880.

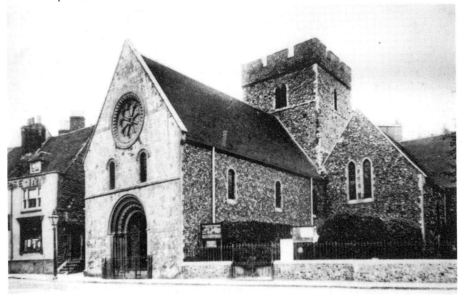

OLD ST JAMES'S CHURCH, across the graveyard, was restored in 1869 by W.J. Adcock and Mr Talbot Bury. The church was destroyed by bombing during the Second World War though the ruins still stand and the doors are in the museum in Ladywell. *Circa* 1925.

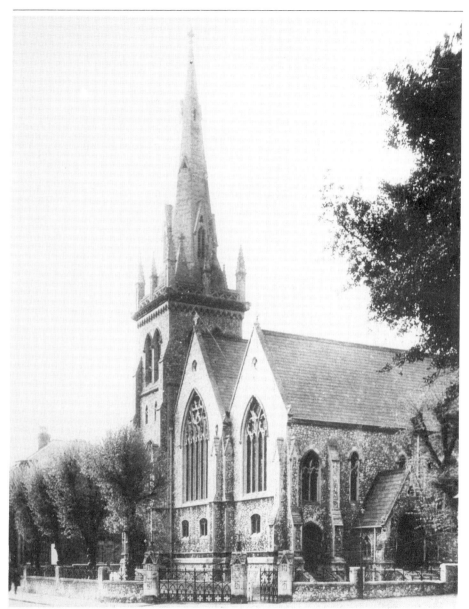

NEW ST JAMES'S CHURCH in Maison Dieu Road was completed in 1862. It was demolished due to war damage. There is very little trace of it left and the site is now used by a local school as playing fields. *Circa* 1925.

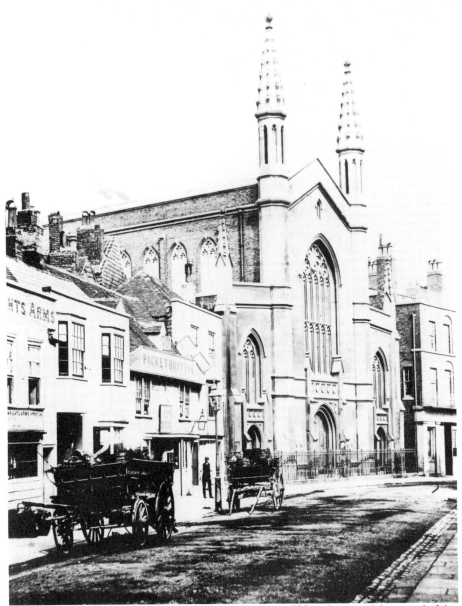

TRINITY CHURCH. The church in Strond Street was built in 1833 and survived the arrival of the railway. It was finally demolished in 1945 with the other remains of Strond Street. 1868.

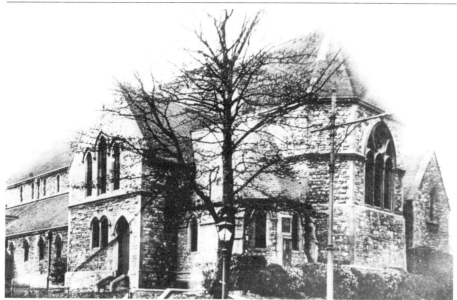

ST BARTHOLOMEW'S CHURCH. At the corner of Templar Street and London Road, St Bartholomew's Church was built in 1877. It has been demolished and replaced by a block of flats.

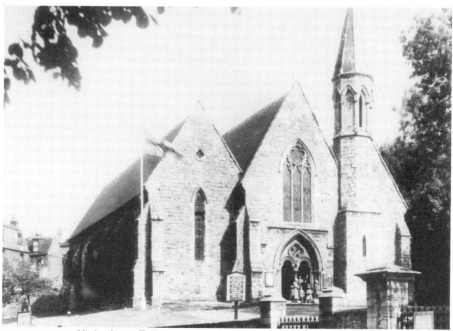

CHRIST CHURCH. High above Folkestone Road stood Christ Church. Opened in 1844, it was demolished in 1977. The land has remained vacant since.

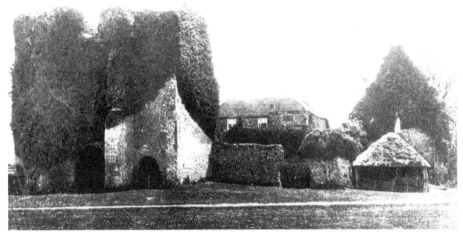

ST RADIGUND'S ABBEY. Otherwise known as Bradsole Abbey, Bradsole meaning broad pond. From left to right, the cloister door and tower, the south wall of the nave, the north-east corner of the forensic parlour. It remains to this day a farm. *Circa* 1900.

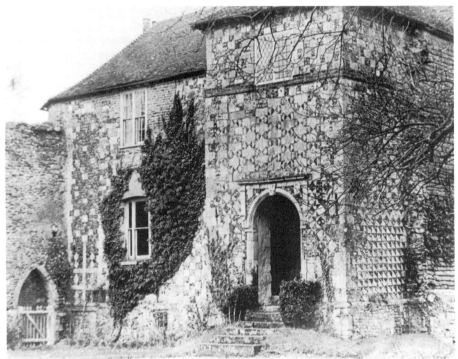

ST RADIGUND'S ABBEY. The Abbey was founded in 1191. This photograph shows the main building of the Abbey after its conversion into a farmhouse. *Circa* 1890.

SECTION EIGHT

Transport

Dover's importance, as always, intertwined with the transit of people from Britain to the Continent, was further emphasized by the coming of the South Eastern Railway on 7 February 1844, which allowed greater freedom of movement for people throughout the country.

The South Eastern Railway's Town station was designed by Lewis Cubitt whose original plans were for a much more ambitious station than the one that opened in 1844. At one time, despite being so remote, it was the only station in Dover. It ceased to be a public station from the outbreak of the First World War when it became a troop station. Between 1915 and 1919 the line was rendered useless by a cliff fall and when re-opened was re-directed to Marine station. In 1927 the western end of the station was demolished.

Today the main railway station is Priory station. This station, originally built in 1860, was enlarged in 1932. In 1868, the original station was the site of a murder. Thomas Wells, an 18-year-old carriage cleaner, shot Edward Walsh, a superintendent, through the head following a disagreement. He made no attempt to escape and at his trial was found guilty and sentenced to hang. He was the first man to be hanged after the abolition of public hanging, in Maidstone Jail in August 1868.

Marine station was designed by Mr P. Tempest for the South Eastern and Chatham Railway on the widened entrance to Admiralty Pier in 1913. It suffered greatly during both world wars. Having been badly damaged by a bomb in the First World War, one of the 700-ft.-long platforms suffered again in 1940, a shell landing in a near identical place to the previous bomb.

With the coming of the railways, certain sacrifices were made to the landscape around Dover. When a tunnel was required to bring the railway to Dover, Rounddown Cliff, a more prominent cliff than Shakespeare Cliff, was destroyed involving an enormous explosion and debris of more than one million tons of chalk.

Until the reliable electricity supply made an electric tramway feasible, horse-drawn buses were a familiar sight. One of the earliest operators was the Sneller family who started in 1878 with a route between Buckland and the Town station.

In 1897 Alderman Baker opened the electric tramway in Dover and for more than 30 years the trams were a familiar sight and sound around the town. The tram line cost £28,000 and the charge was 1d. In the first year the line was used by 1,794,905 passengers, making a profit of £1,300.

This cheap means of transport ran through almost every area of the town, along streets now long since vanished. For instance, Tram 2 ran along Crosswall, Strond Street, George Corner, Snargate Street, Courts Corner, Northampton Street, New Bridge, Bench Street, King Street, Market Place, Cannon Street, Biggin Street, High Street, London Road and Canterbury Road to the extended boundary.

The trams however, met stiff competition from the bus company which did not require tracks and did not obstruct the road for other users. From midnight on the 31 December 1936, the tramway was abolished and was replaced by the bus service.

The East Kent Bus Company was founded in August 1916 by an amalgamation of five small local companies: Deal & District Motor Services; Folkestone & District Road Car Co.; Margate, Canterbury and District Motor Services; Ramsgate Motor Coaches (Griggs Ltd.); and Wacher & Co. Ltd. of Herne Bay. This company remains in operation to the present day.

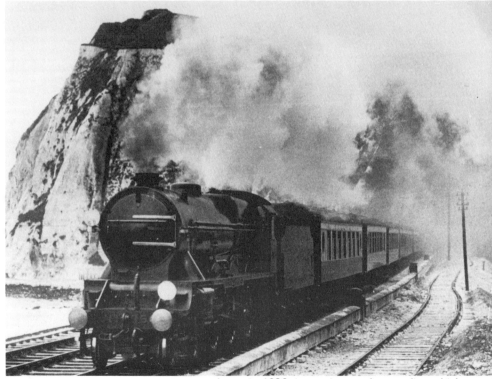

THIS 'LORD NELSON' CLASS STEAM ENGINE, shown in 1928, is running on the new line which replaced the wooden viaduct. In the background is Shakespeare Cliff.

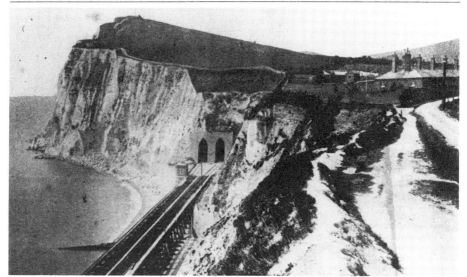

HAY CLIFF VIADUCT from the top of the cliff on Old Folkestone Road. The tunnel through Shakespeare Cliff was built in 1843 following the destruction of Rounddown Cliff. The wooden viaduct known as Hay Cliff Bay Viaduct was finally removed in 1927. To the right are the houses which now form part of Aycliffe.

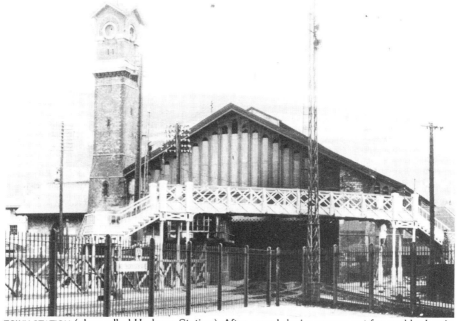

TOWN STATION (also called Harbour Station). After grand designs were put forward by Lewis Cubitt, a rather more modest station was eventually built in 1844. Though closed in 1914 parts of the station still remain standing.

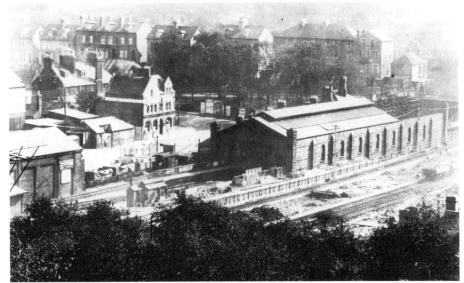

PRIORY STATION was opened in 1860 and was extended in 1932 as shown here. To the left of the main building is the Priory Hotel and behind that, Gardner's Brewery. Beyond the station is Folkestone Road.

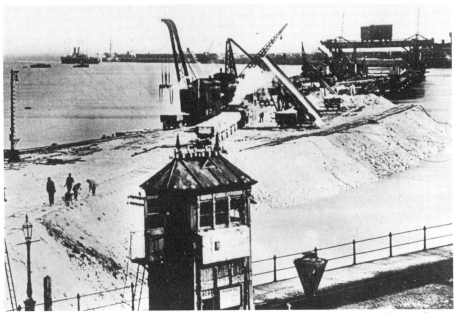

THE NEW MARINE STATION WORKS from the Lord Warden Hotel. The station, built for the South Eastern and Chatham Railway, was designed by Mr P. Tempest. *Circa* 1910.

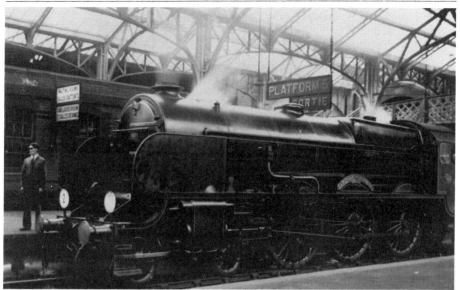

MARINE STATION. At Platform 5 of Marine station is the locomotive *Sir Richard Greville*, 1936. During both world wars the station received direct hits in identical places.

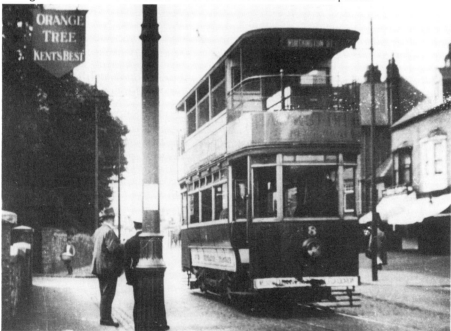

TRAM NO. 8 at the Orange Tree pub outside the Maxton Garage. The route to Maxton was along Folkestone Road and opened in 1901. No. 8 was also believed to have been used as a waiting room at the terminus after it went out of service.

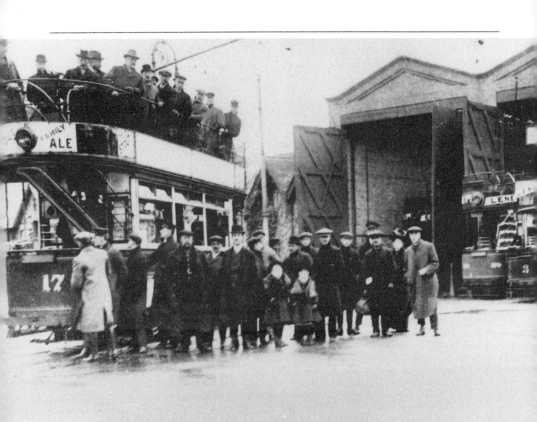

THE FIRST SUNDAY TRAM

THE FIRST SUNDAY TRAM. The Sunday tram service began in March 1911 from outside the Buckland Garage, opposite the Buckland Paper Mill. This building is now a car showroom, which for many years retained the tramlines inside.

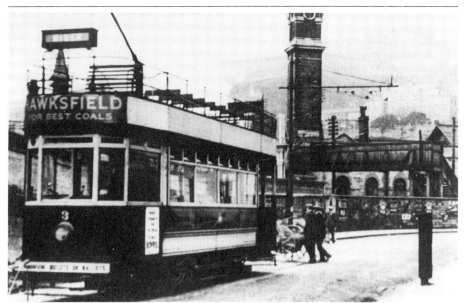

TRAM NO. 3 at Town Station. The ex-Peckham trailer is outside the Town station, c. 1925. The Buckland to Town station route was part of the first to be opened, in 1897. No. 3 was scrapped in 1927.

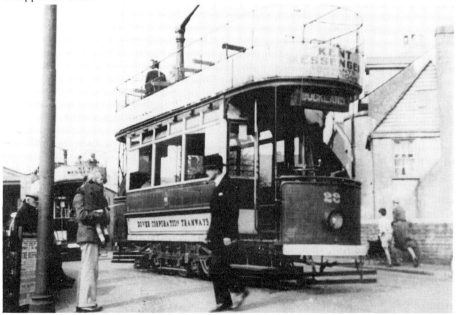

TRAM NO. 22 at Buckland Bridge on the corner of London Road. The building on the left is the Buckland Garage. No. 22 was later converted for open top use for the service to River and was scrapped in 1933. *Circa* 1930.

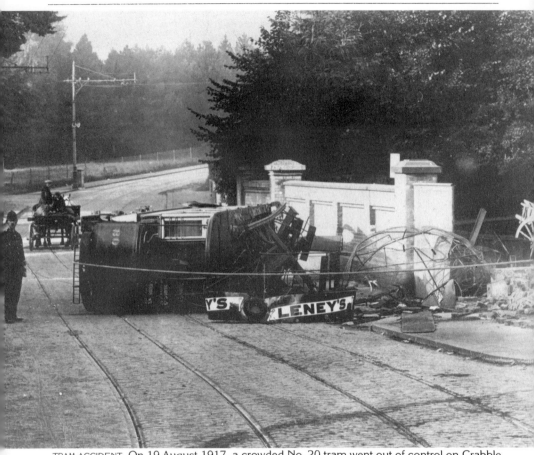

TRAM ACCIDENT. On 19 August 1917, a crowded No. 20 tram went out of control on Crabble Hill. The driver, who had managed to jump clear, claimed the brakes failed. The tram crashed into the wall of the paper mill and turned over, crushing the top deck and killing 11, amongst them the conductress Miss Lottie Scrase, and injuring 60 other passengers.

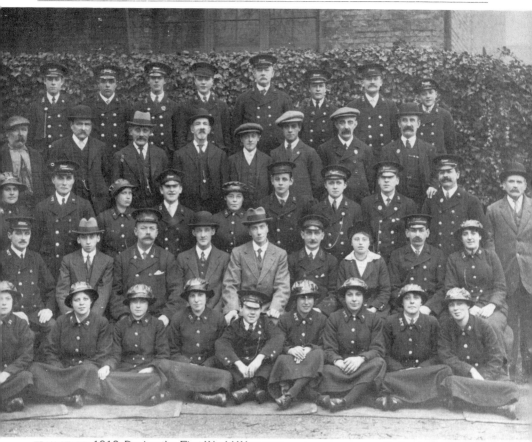

TRAM STAFF, 1918. During the First World War young women were recruited onto the staff as well as discharged soldiers. From the back, left to right, J. Heath; P. Sutton; A. Barnett; A. Bishop; H. Blackman; A. Beeney; F. Hogben; A. Smith. W. Stamer; E. Tarver; E. Sutton; W. Fuller; A. Robertson; J. Ridge; E. Nye; A. Budd. B. Gausden; G. Lester; E. Wright; A. Birch; E. Streat; V. Ready; H. Little; W. Muscott; J. Nolan; F. Harmer. E. West; B.W. Jones (Management Clerk); H. Elgar (Inspector); A. Robertson (Electrician); E.H. Bond (General Manager); F.C. Pay (Inspector); P. Brewster (Ticket Clerk); H. Brett; L. Grant. S. Bond; E. Lentz; A. Bean; S. Edwardes; A. Couchman; M. Lawrence; F. Edwardes; M. Smith; D. Burke. Not shown: W. Brooks; E. Nye; E. Sole; H. Creed; W. Knott.

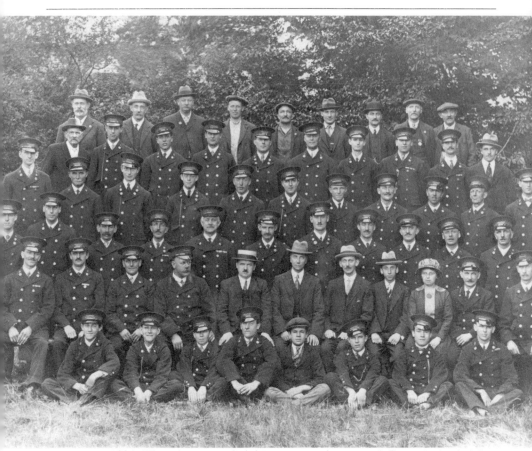

TRAM STAFF, 1921: When the war ended things returned to normal. From the back, left to right: W. Brooks; E. Nye; E. Sole; H. Creed; W. Knott; A. Russ; E. West; E. Bridger; R. Sutton. E. Tarver; F. Powell; W. Gausden; G. Attwood; H. Cole; H. May; P. Stacey; W. Murcott; A. Dyer; V. Pilcher. F. Godden; G. Lester; A. Dolbear; H. Dixon; C. Matthews; W. Knott; G. Archer; F. Hogben; R. Russell; H. Vallintine; A. Larkin. J. Heath; F.C. Clayton; H. Brett; W. Turner; G. Whiteman; H. Hambrook; A.C. Binge; G. Bass; W. Pay; A. Baily; A. Abbott; C. Deverson. H. Else; D. Gibb, F. Holt (Checker); H. Elgar (Inspector); A. Pollard (Depot Superintendent); E.H. Bond (General Manager); S.A. Goodwin (Traffic Clerk); B.W. Jones (Management Clerk); D. Brewster (Ticket Clerk); F.C. Pay (Inspector); A.E. Binge (Acting Inspector). Front Row: S. Goodburn; F. Smith; R. George; C. Gambrell; W. Wyborn; C. George; A. Couchman; J. Hatton. It is interesting to compare this and the previous picture.

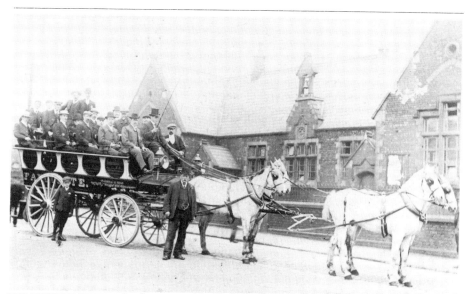

THIS HORSE-DRAWN BUS is shown outside Buckland School in London Road and operated between Buckland and the railway station. Such services operated before the emergence of the electrified tramway.

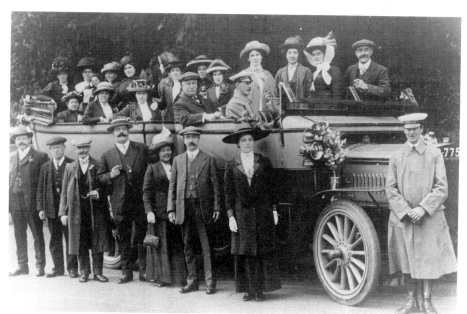

EAST KENT BUS 1916. While the East Kent Bus Company was founded in 1916, its dominance did not become complete until 31 December 1936 when the tram service was ended in favour of the bus system.

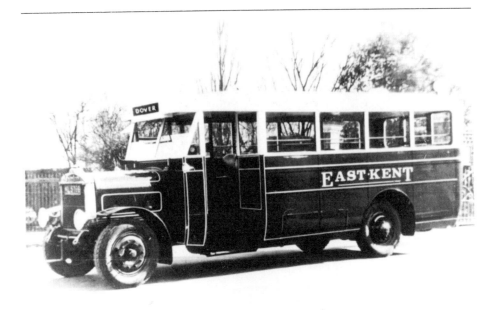

A 1920 DAIMLER whose charabanc body had been replaced by a Leyland lTD Elvington piano front.

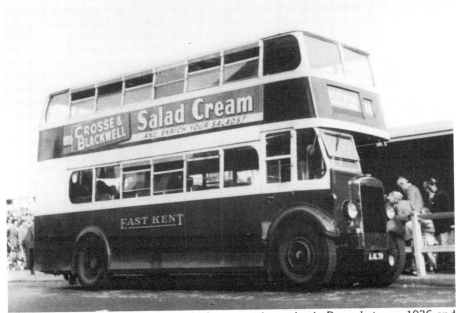

A LEYLAND TD 4 double-decker bus which was put in service in Dover between 1936 and 1939. This one carries advertising space for Crosse and Blackwell Salad Cream.

SECTION NINE

People

Dover's position as the premier port of Britain has meant that it has been the destination point for countless people over hundreds of years. Some famous and not-so-famous people have been given a warm welcome by the townspeople on their way through the port.

But beneath the ceremonial and public surface are the people who in their own way have shaped the course and influence of the town and there are those who have added to the town's character by their presence.

Sir William Crundell, who was mayor ten times in thirteen years, was a most influential man in Dover politics and did much to shape the town. As a Conservative councillor he served as the council's representative on the Harbour Board, which administers the harbour to the present day, until an unprecedented row with the Liberal Chairman, Lord Granville, resulted in his sacking from the board. Not one to take defeat lightly, in the ensuing political battle for control of the harbour, Crundell nearly succeeded in wresting power away from the Harbour Board and into the hands of the council until his case was stopped in the House of Lords. Eventually, Crundell became Chairman himself.

An equally influential man in Dover politics was William J. Barnes, an ally of Sir William Crundell. A chemist, he served as mayor in 1900, and during the First World War he served as a nightwatchman and as a special constable.

Another man in Dover's history with an interesting life was George Richard Shilson, who owned the Slipway repair yard and was a member of the Society of Associated Shipwrights in 1890. Between 1878 and 1883 he was the landlord of the Grand Sultan public house in Snargate Street. In 1895 he was the proprietor of the Harbour Temperance Hotel on Custom House Quay. He was also a sergeant in the Volunteer Militia in 1899.

Dover has honoured many of those who have honoured Dover by their actions and their service. Not least is Sir Roger Keyes, mastermind of the heroic Zeebrugge Raid, who on his death was buried at Dover alongside those men who died on St George's Day 1918.

The people of Dover have also been pleased to honour those who they have taken to their hearts and those who have taken Dover to their hearts.

Not surprisingly many famous people and heads of state and government have found it necessary to pass through Dover on their way to or from history-making events. Those personages involved in events in the past were always welcomed enthusiastically when passing through Dover.

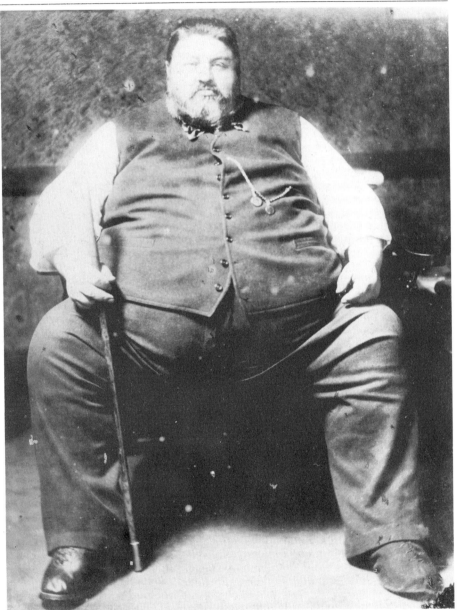

THOMAS LONGLEY, 1903, landlord of the Star Inn in Church Street, was at one time the heaviest British subject in the world, weighing 593lb. He once received a letter from Queen Victoria complimenting him on his good health. He was, however, a virtual prisoner in one room for many years. He died in 1904, aged 58. The coffin was over seven feet in length and required 12 bearers to carry it the short distance from the Star Inn to St Mary's Church, having first removed it from the pub via the window.

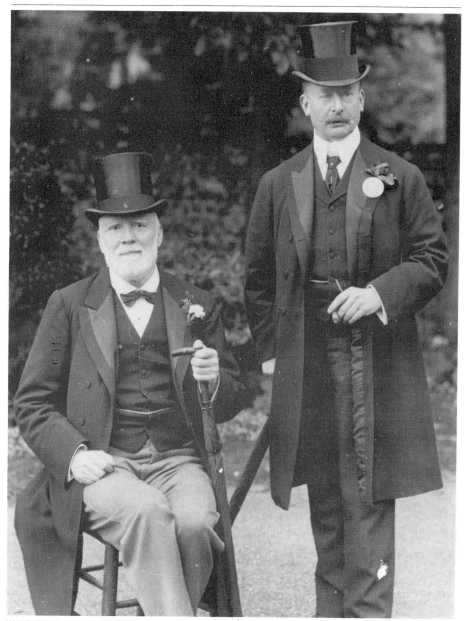

W.J. BARNES AND SIR WILLIAM CRUNDELL were two former mayors of Dover. Crundell, right, was Mayor thirteen times and the Chairman of the Harbour Board. William J. Barnes, left, was also a chemist and honorary curator of Dover Museum, 1900–1935.

DR EDWARD ASTLEY (1812–1907), was physician to the Royal Victoria Hospital for sixty years. He was an alderman, a major in the Volunteer Militia and was honorary curator of Dover Museum from 1856 to 1900. He presented the organ in the Connaught Hall as a gift to the town and he was on the committee that set up the Connaught Park and donated a fountain.

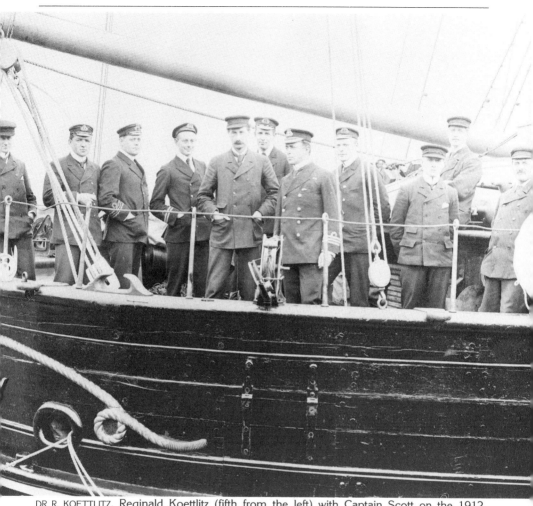

DR R. KOETTLITZ. Reginald Koettlitz (fifth from the left) with Captain Scott on the 1912 expedition, as senior medical officer. His son, Maurice, donated the polar bear which his father brought back from the Jackson-Harmsworth Expedition of 1894–7 to the museum, where it now stands in the doorway, it having stood in his surgery for many years. He went to live in South Africa, where he died from dysentery on the same day as his wife.

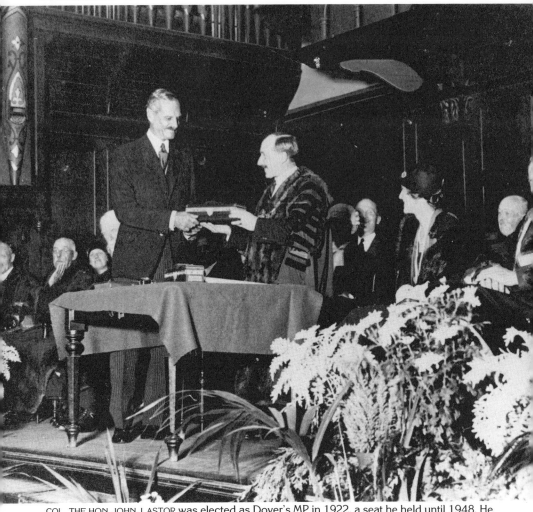

COL., THE HON. JOHN J. ASTOR was elected as Dover's MP in 1922, a seat he held until 1948. He received the Freedom of Dover, together with his wife Lady Violet Mary Astor, from F.H. Morecroft, the Mayor, at the Town Hall on 27 September 1933. Prior to this he donated a dental clinic to the town which opened the same year and which was demolished along with Brook House in 1988.

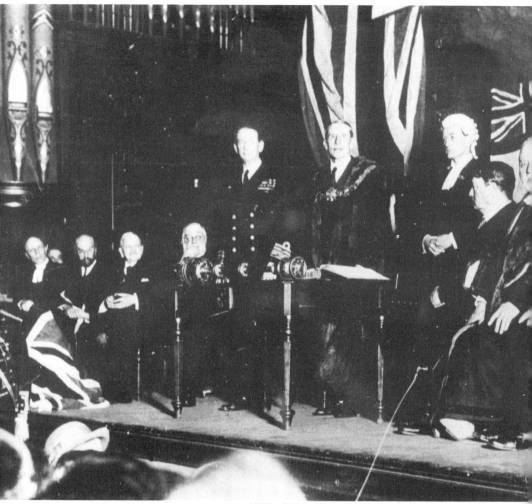

ADMIRAL SIR ROGER JOHN BROWNLOW KEYES KCB, CMG, MVO, DSO, Admiral of the Fleet, Commanding Officer of the Dover Patrol and the mastermind behind the raid on Zeebrugge, received the Freedom of Dover on 12 December 1918. After his death, Sir Roger was buried in St James's Cemetery with the men that died during the Zeebrugge Raid.

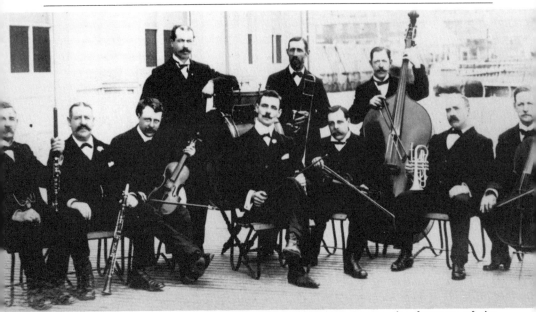

DOVER PROMENADE ORCHESTRA. In 1906, in an attempt to revive the fortunes of the Promenade Pier, a pavilion was built and an orchestra hired to entertain the visitors. The pier closed in 1913.

GORDON BOYS' HOME was founded by A.T. Blackman in memory of General Gordon in 1882 as the Orphans' Seaside Rest in Liverpool Street near the seafront. The school moved to St James's Street in 1885. Mr Blackman is the portly man in the centre. They were evacuated in 1940 and did not return.

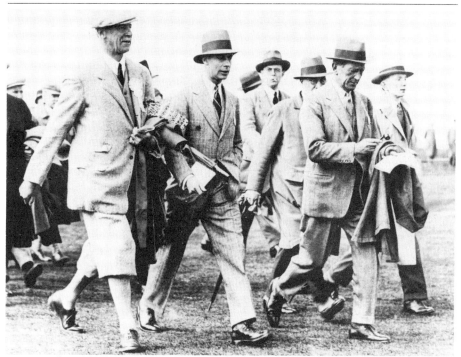

GEORGE VI. Dover has received many royal visitors. Charles II landed in Dover to reclaim the crown. Prince Albert landed in Dover prior to his marriage to Queen Victoria. Edward VII, while Prince of Wales, opened the pier named after him. George VI, like his father, visited Dover in both peacetime and in wartime. 1935.

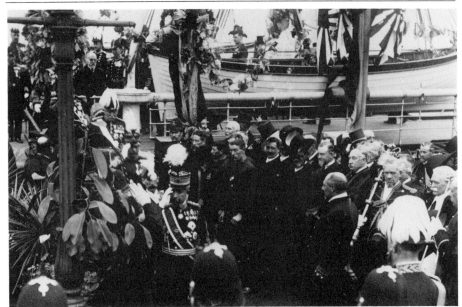

PRINCE FUSHIMI OF JAPAN. Foreign royalty has also passed through Dover. In May 1907 Prince Fushimi of Japan landed at Admiralty Pier and was enthusiastically greeted. In June 1907, Dover greeted the King of Siam on his arrival in Britain.

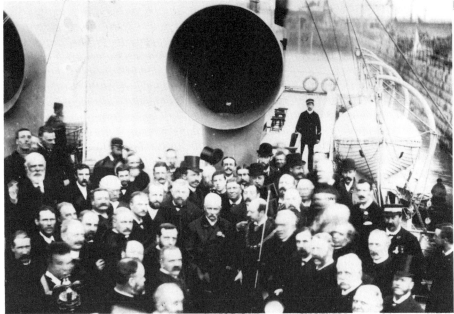

SIR HENRY STANLEY, (centre) of 'Dr Livingstone I presume?' fame passed through Dover in 1890, attracting a large welcoming reception.

SECTION TEN

Events

Dover's military past ensured that celebrations of historic events were frequently large and well supported. Military displays, marches and parades were the order of the day whenever the occasion befitted.

During the Volunteer Reviews, several thousand soldiers were engaged in sham battles and skirmishes over the downs around Dover, often for distances of many miles and included the Royal Navy as well. On 26 March 1869 HMS Ferret, an 8-gun brig with 20 men and 80 boys on board, was wrecked when heavy seas smashed the vessel into the Admiralty Pier in front of hundreds of spectators. Fortunately all were rescued.

'Welcome Volunteers!' read the archway in Biggin Street built for the Volunteer Review of 1869. The verse continued; 'Foreign foe and false beguiling,/ shall our union ne'er betide./ Hand in hand when peace is smiling/ and in battle, side by side./ God bless the gallant British hearts,/ whom now we welcome here.'

Dover, with its large system of fortifications and vast military accommodation facilities, could easily host the ambitious Volunteer Review which involved well over 7,000 soldiers.

This close affinity with the military brought a strong sense of relief at the end of the First World War and a shared sense of loss as Dover paid its respects to those who gave their lives.

Dover's wealth of history provided the inspiration behind the Dover Pageant of 1908 in which over 2,000 people performed seven episodes tracing the history of Dover from King Arthur to Charles I. The Master of the Pageant and principal author was the well-known author and playwright, Mr Louis Parker. The music was provided by Mr H.J. Taylor organist to the Corporation of Dover, with 100 musicians under his direction. Some of Dover's notable people, including the headmaster of the Boy's Grammar School, Mr Fred Whitehouse, headmaster of the Gordon Boys' School, Mr T. Blackman, and some of his pupils, Mr Whorwell, a well-known Dover photographer responsible for some of these photographs, and the chemist and Mayor, W.J. Barnes also performed.

Unfortunately, though the Pageant was a success as far as being a spectacle was concerned, it was a financial disaster.

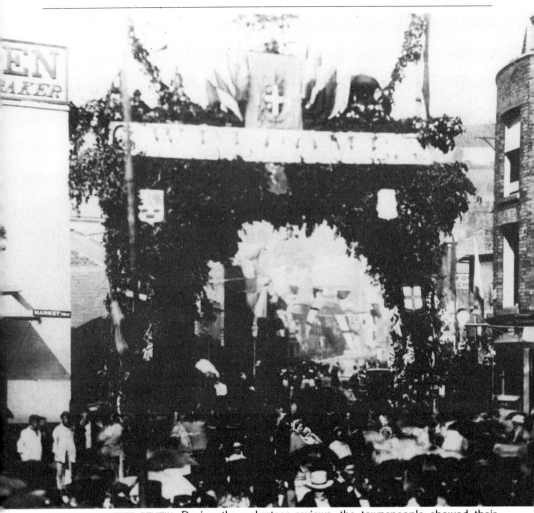

DOVER VOLUNTEER REVIEW. During the volunteer reviews, the townspeople showed their enthusiasm by building these Welcome Arches throughout the town. This arch is at the corner of Market Square and Castle Street. Igglesden's restaurant and bakery is to the left.

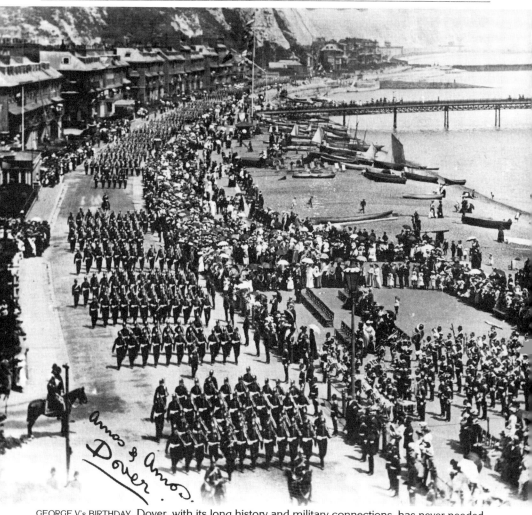

GEORGE V's BIRTHDAY. Dover, with its long history and military connections, has never needed much of an excuse for a celebration or a parade. Here it is George V's birthday in 1910 with a marching display along the Marine Parade, looking towards the Eastern Docks. The Promenade Pier is to the right.

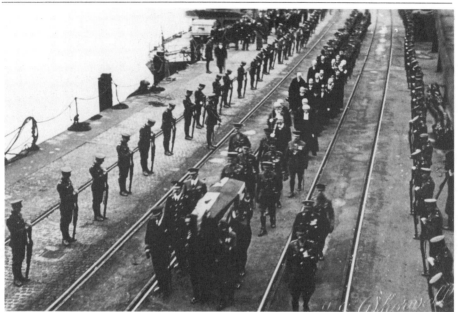

THE ROUTE OF THIS FUNERAL CORTEGE ALONG THE PIER is lined with military personnel and members of the hospital services. The body of Nurse Edith Cavell was landed at the Promenade Pier in Dover. *Circa* 1919.

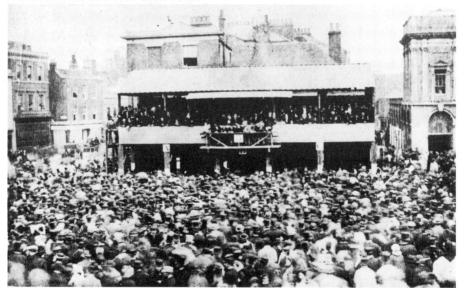

DOVER HUSTINGS. The Hustings of the Dover Election in 1865 between the Conservatives, Maj. Alexander Dickson and Charles K. Freshfield, and the Liberals Lord Bury and Eustace Smith. The Conservatives were elected. In 1885 Dover's two MPs were reduced to one. To the right is the Market Place, which was badly damaged in 1940.

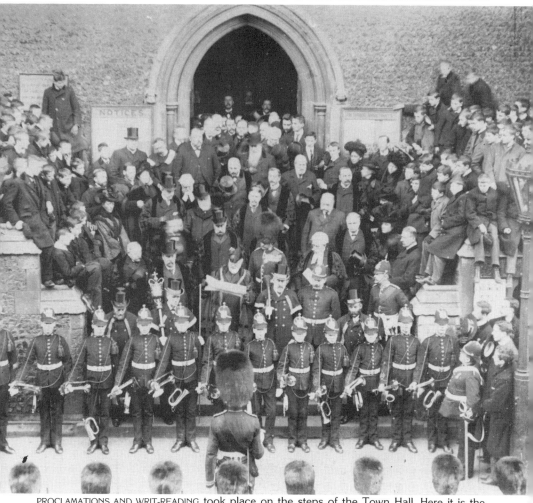

PROCLAMATIONS AND WRIT-READING took place on the steps of the Town Hall. Here it is the proclamation of the accession of Edward VII with the Mayor, Frederick George Wright, reading the address.

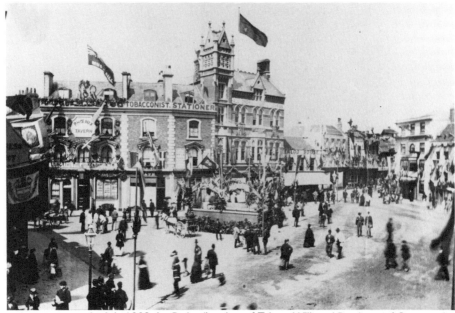

CONNAUGHT VISIT. In July 1883 the Duke (brother of Edward VII) and Duchess of Connaught, were invited to Dover to open the park named after them, and the tree the Duchess planted still survives today. Decorations adorned Market Square for the occasion.

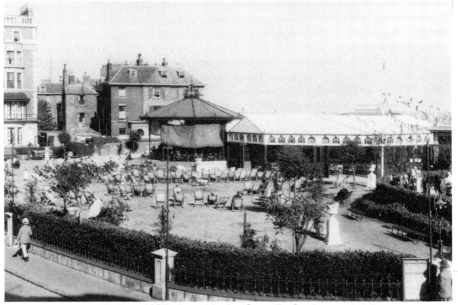

THE BANDSTAND was built in 1925 alongside the Granville Gardens and did not survive the war, though the gardens were enlarged following the construction of the Gateway flats.

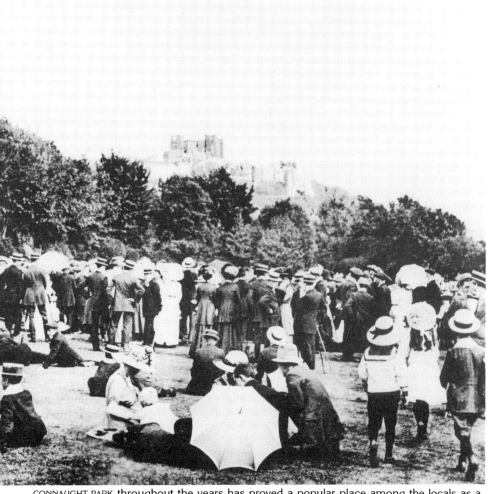

CONNAUGHT PARK throughout the years has proved a popular place among the locals as a place of relaxation, such as on this Sunday afternoon, c. 1910.

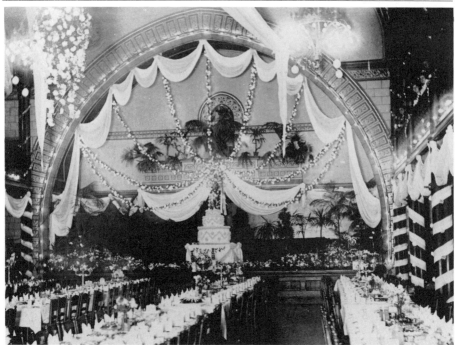

CHILDREN'S PARTY. On 5 February 1902 a party was held for the town's children at the Town Hall. It was organised and paid for by the Mayor, Martyn Mowll, in celebration of his term of office. Four hundred and thirty children attended and the decorations were provided by a well-known local firm, Flashman's.

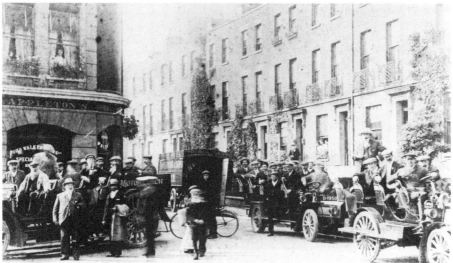

THE DOVER VICTUALLERS on their annual outing, gathered at the corner of High Street and Priory Street. The pub behind is the Prince Albert, which still stands today. *Circa* 1895.

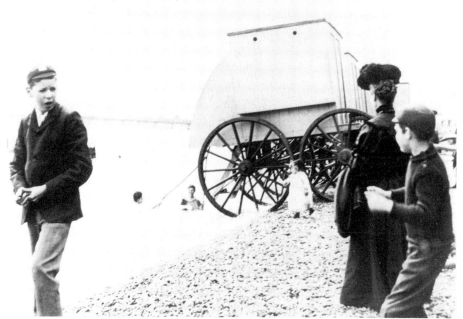

BATHING MACHINES. Dover has had bathing machines since the early nineteenth century. These were popular at this time, as were Marsh's Royal Baths along the seafront.

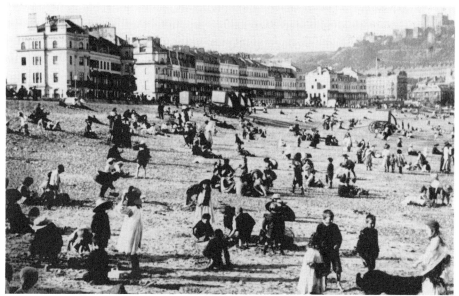

DOVER BEACH. The crowded beach at the eastern end with the Connaught Hotel and Waterloo Crescent in the background.

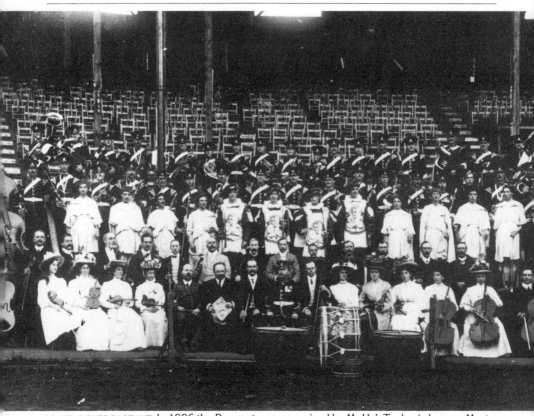

BAND, DOVER PAGEANT. In 1906 the Pageant was conceived by Mr H.J. Taylor (who was Master of the Music) and Mr Louis Parker (who was Master of the Pageant) to celebrate the History of Britain. The band, consisting of 100 musicians, played in the grounds of Dover College where College Close formed an arena. A stand accommodating 5,000 spectators was erected in front of the school house.

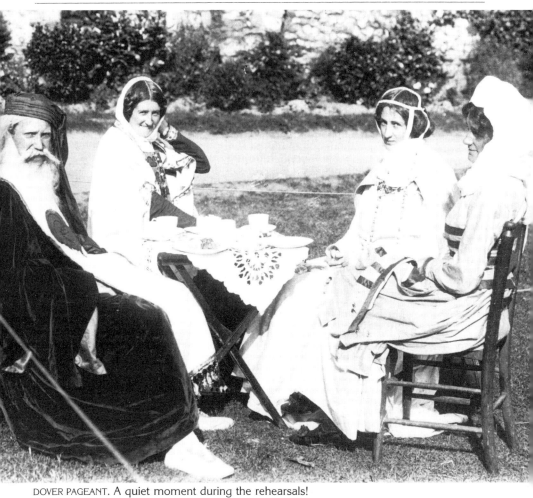

DOVER PAGEANT. A quiet moment during the rehearsals!

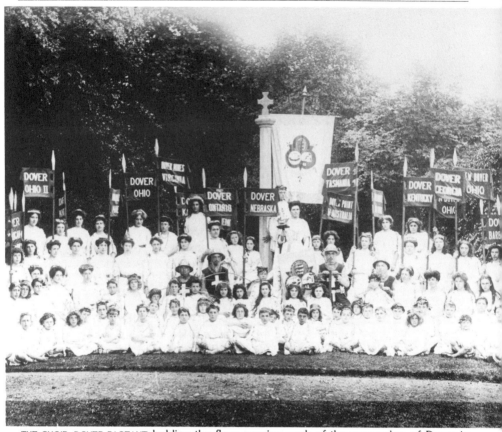

THE CHOIR, DOVER PAGEANT holding the flags naming each of the namesakes of Dover in countries throughout the world including Canada, Australia and several in the United States of America. The flag at the back shows the emblem of the Cinque Ports.

Cinque Ports

The Confederation of Cinque Ports (pronounced 'Sink' not 'Sank') was founded in the eleventh century during the reign of Edward the Confessor. In return for certain privileges for the freemen of the member towns, the members provided ships and men for 15 days a year free service to the Crown.

The original rights were as follows: 'Exemption from Tax and Tallage, Sac and Soc, Toll and Team, Blodwit, Fledwit, Pillory and Tumbrill, Infrangentheof, Outfrangenof, Mundbryce, Waifs and Strays, right to Flotsom, Jetsam or Legan, Privilege of Assembly as a guild, Rights of Den and Strond, and Honours at Court.'

These rights gave Portsmen full self government, allowing them the organisation of their own taxation and legal affairs. The Portsmen also had their own courts, could judge and punish criminals, levy tolls and claim any wreckage found in the sea or on the shore. Their special honours at court gave them the right to carry a canopy over the king at his coronation and sit at his side at the coronation feast.

Such power and position was considerable and open to abuse. Unofficial piracy, robbery and pillage were commonplace among Portsmen until the early thirteenth century when the King created the position of Lord Warden in an attempt to control their activities, and combined it with that of Constable of Dover Castle.

Among those who have served as Lord Warden of the Cinque Ports are the Duke of Wellington, Winston Churchill and, presently, Her Majesty Queen Elizabeth, the Queen Mother.

The Baron's duties at the coronation were dispensed with by William IV and by Queen Victoria and were last invited in 1902 for the coronation of Edward VII, though their participation was reduced to carrying the four standards of England, Scotland, Ireland and the Union. The four Barons chosen for this honour were Martyn Mowll, Mayor of Dover; Mr Langham, Mayor of Hastings; Mr Stafford Charles, Mayor of Romney; and Mr Inderwick, Mayor of Winchelsea.

The courts were originally empowered to deal with all cases, both civil and criminal. The mayor of each port could try persons for all offences except treason and dispense all sentences from the pillory to the death penalty. Since this time of course, those powers of adjudication have been removed by many Acts of Parliament.

A Court of Brotherhood was an assembly of the five ports (Dover, Sandwich, Hythe, Romney and Hastings) and the two Ancient Townes (Rye and Winchelsea), while a Court of Brotherhood and Guestling was a general assembly of the Ports, Ancient Towns and all the corporate members. In later years these courts were held to vote an address of congratulation as in 1897 on Queen Victoria's Jubilee and in 1902 to congratulate King Edward VII on his Coronation.

Traditionally, the installation ceremony of the Lord Warden took place at the remains of the second Roman lighthouse, known as the Bredenstone, on the Western Heights. More recently, the ceremony has taken place within the grounds of the Priory, now Dover College.

In addition to ceremonial functions, the Cinque Ports have brought people together on many other occasions. The great Cinque Ports Volunteer Reviews in 1860 and 1869 brought many thousands of people into Dover to watch and to participate in the mock battle around Dover's fields and shores. The wrecking of the brig HMS **Ferret** in Dover Harbour during the 1869 review could easily have resulted in a tragedy far greater than the 1860 explosion at Archcliff Fort which killed Lieut. George Thompson and Sgt. John Monger.

Though the stature of such ceremonial functions may have declined with the years, their existence has strengthened the heritage of the town of Dover.

LORD WARDEN CEREMONY. The Marquis of Dufferin and Ava (Frederick Blackwood) was appointed Lord Warden of the Cinque Ports. His inauguration took place on 22 June 1892 at the ancient Bredenstone on the Western Heights where all the previous ceremonies had taken place since the seventeenth century. It was only held there on one other later occasion, at Earl Beauchamp's installation in 1913.

LORD WARDEN CEREMONY. In May 1904, George Nathaniel Curzon, the Marquis of Kedleston, was appointed Lord Warden, following the death of the Marquis of Dufferin and Ava. His ceremony took place in the grounds of Dover College, now the favoured site and where the Queen Mother's ceremony took place in 1984.

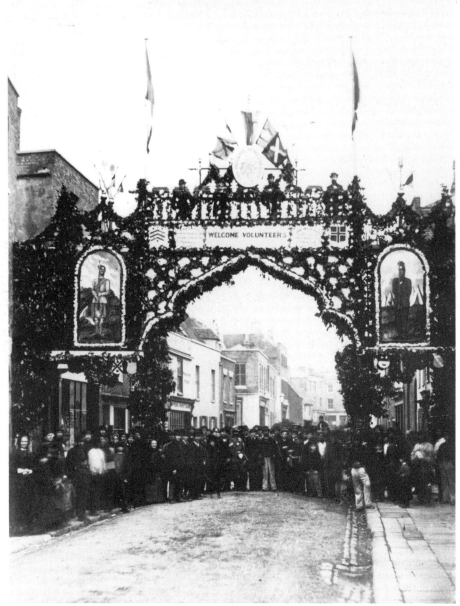

VOLUNTEER REVIEW ARCH. For the 1869 Review this archway of welcome was erected in Biggin Street. To the left, beyond the arch, is Penn Bros., a cabinet-makers, upholsterers and undertakers.

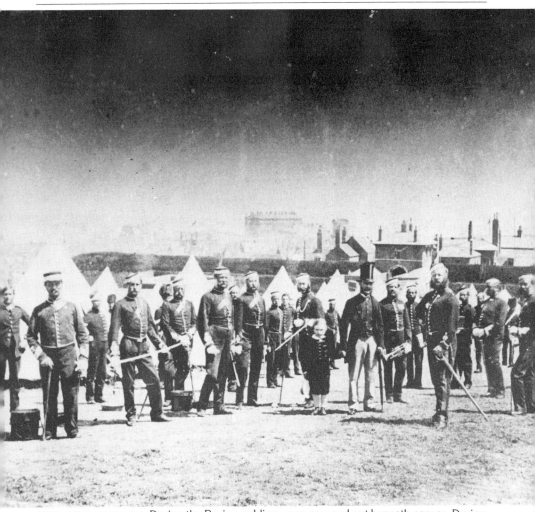

ROYAL ARTILLERY MILITIA. During the Review soldiers were camped out beneath canvas. During the 1865 Review almost 7,000 troops took part, including these men from the Dover Volunteer Militia.

LIEUT. G. THOMPSON. The 1860 Volunteer Review suffered a tragedy when the explosion of an artillery gun at Archcliff Fort killed Lieut. George Thompson and Sgt. John Monger. The inquest was delayed because Lieut. Thompson was the coroner for Dover.

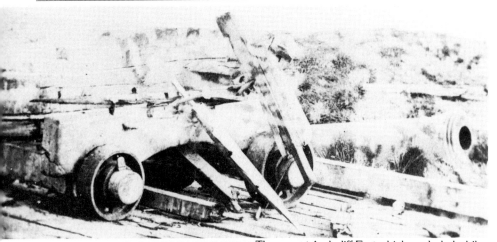

THE GUN WHICH KILLED THOMPSON AND MONGER. The gun at Archcliff Fort which exploded while firing during the Review. While Thompson's funeral was a small family affair, Monger received a large military funeral. A obelisk was later erected in Cowgate Cemetery to Monger by the officers and men of the regiment, which can still be seen today.

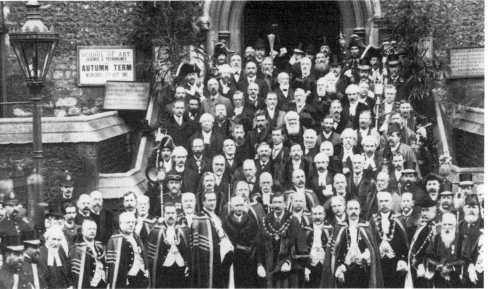

BROTHERHOOD AND GUESTLING outside the Town Hall in 1925. It may be said that the Court of Brotherhood was the parliament of the Cinque Ports while at the same time maintaining their rights as individual towns. The Court of Brotherhood was an assembly of the five ports and two ancient towns while a Court of Brotherhood and Guestling was a general assembly of the representatives of the 'Ports, Ancient Towns and all the Corporate members'. The meeting in Dover in 1887 (and again in 1897) to present an address of congratulations to Queen Victoria in her jubilee year was the first in 312 years in Dover. This meeting in 1925 was to entrust the Charter of Charles II and the Cinque Ports flag into Dover's care.

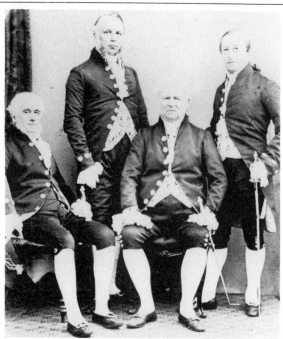

FOUR BARONS OF DOVER IN THEIR CORONATION DRESS. The last occasion they performed any ceremonial duty at a coronation was that of Edward VII, in 1910.

ACKNOWLEDGEMENTS

There are many people whom I would like to thank for their interest and assistance in the compilation of this book.

I would like to thank Mr Donald Cook for the use of his photograph, Oil Mill Barracks, which is a rare view of an old and long since demolished building.

Also to Andrew Denyer for providing me with an excellent copy of the photograph of the Maison Dieu and tram c. 1900.

I must thank Mr Harold Sneller and Mr Joe Harman not only for the kind use of their photographs but also for their enthusiasm for Dover and its history.

I also offer my thanks to the staff of the Dover Museum (Ian Waters, Christine Cheffins, Tracy Morton, Kathryn Goldsack, Cheryl Norton, Brian Ricks and John Marsh amongst others), all of whose warm and friendly assistance has so greatly contributed to my enjoyment of this project.

And to Christine Waterman, the Curator of the Museum, for her Introduction and for her time and without whom this book would never have been done.

Most of all, I thank my family and friends for their support and assistance from beginning to end.